The Best in
World Trademarks
Corporate & Brand Identity

Volume. 1

Copyright 2005
by SANSUNG Publishing Company.

Publisher
Cho, Young-Sung
Editor
Kwon, Young-Soo

Distributed by DONGNAM.
2-5, Itaewon-Dong YongSan-gu,
Seoul, Korea.
TEL:02-790-0690

ISBN 89-951198-1-0

FOREWORD

어떠한 단체나 기업들은 자신들이 누구이며 무엇을 하며

어떻게 그 일을 하는지를 하나의 이미지로 통합하여 시각적으로 전달하는

CI를 가지고 있다. 또한 작은 바늘 하나에서 부터 자동차에 이르기까지

국경이 없는 무한경쟁 시대의 많은 상품들은 브랜드의 유명세에 따라

판매 결과가 판가름 난다는 사실과 상품에 있어 Brand의 중요성은

그 누구도 부인할 수 없을 것이다. 상품이 꼭 디자인이나 기업의 이미지에

의해서만 소비자에게 선택 된다고는 볼 수 없지만 CI나 BI를 제대로

개발하지 못하거나 관리하지 못해 소비자에게 매력이 없는 이미지를

주는 경우도 있다.

CI 프로젝트는 조사, 분석, 디자인 등 여러분야 전문가들의 팀웍으로

이루어지는 작업이다. 이 가운데 디자이너는 구체적인 작업의뢰를 받고

이미지를 가시화 하는 일을 함으로서 촉매자 역할을 한다.

오늘날 통신수단의 발달로 많은 정보가 수집, 교환되기도 하지만 프로젝트

진행에 있어서 기초 자료수집에 많은 시간과 인력이 동원 되기도 한다.

본 서는 이러한 실무디자인 작업에 있어서 자료의 부족과 시간이 촉박한

상황에서 적당한 디자인 결과물에 대해 만족하고 결론 지으려 하는

현실을 자인하며 디자인 프로젝트에 있어서 기초자료의 역할을 하고자 한다.

본 서의 구성은 복잡 다양한 현대 산업사회의 업종을

약 1500여개 업종으로 크게 구분을 하였으며 그 업종과 관련된

5000여개의 기업 심볼과 유명 브랜드 마크를 정리 수록하였다.

(The Best in World Trademarks)는 디자인 제작사의 실무 디자이너,

광고 기획사, 기업체의 디자인 담당자는 물론

대학에서 디자인을 공부하는 학생에 이르기 까지 폭넓게 이용할 수 있는

CI 디자인 전문 서적이다. 자료집의 모든 내용을 CD-ROM으로 제작하여

실무 디자인작업에 있어 유용하게 사용할 수 있도록 하였다.

권 영 수

 Blackburn
College

Library
01254 292120

Please return this book on or before the last date below

As with religion, politics and education,
everyone has an opinion to express
about design.

Design Park(Korea)

THE BEST IN

WORLD TRADEMARKS

1

Contents

Star Mart

Unleaded	99 9/10
Plus	1.04 9/10
Super	1.09 9/10

Self
Gasoline

Pizza Hut

Corporate

Identity

Brand

Identity

Tokkaebi

ahn graphics 1988.

1
Major League Baseball(USA)

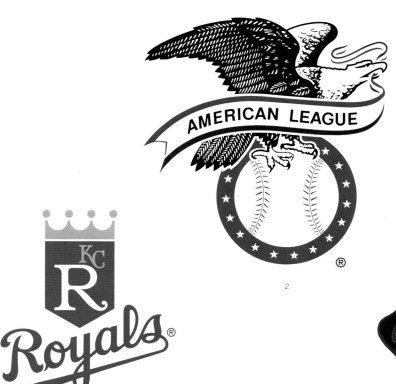

2

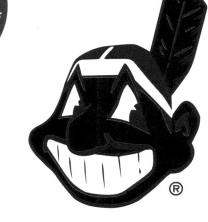

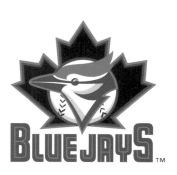

3

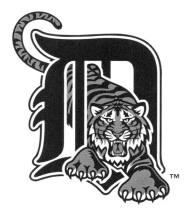

4

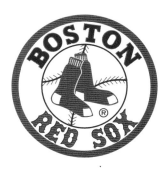

5

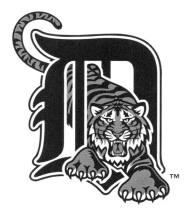

6

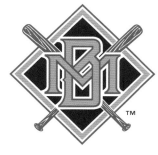

7

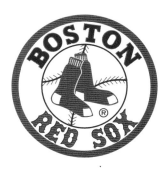

8

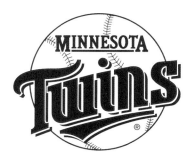

9

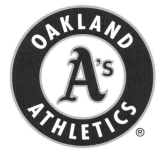

10

11
Seattle Mariners
시애틀 매리너
USA

12
Anaheim Angels
애너하임 엔젤스
USA

13
Wordmark for Cleveland Indians
클리블랜드 인디언즈 워드마크
USA

14
Emblem for New York Yankees
뉴욕양키즈 엠블럼
USA

15
Baltimore Orioles
볼티모어 오리올즈
USA

16
New York Yankees
뉴욕양키즈 이미셜
USA

17
Chicago White Sox
시카고 화이트삭스
USA

18
Arizona Diamondbacks
아리조나 다이아몬드벡스
USA

19
Texas Rangers
텍사스 레인져스
USA

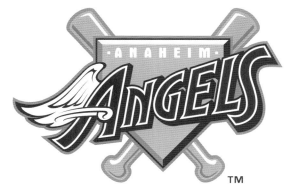

12

11

13

14

15

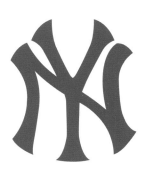

16

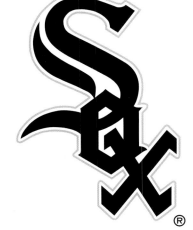

17

18

19

20

21

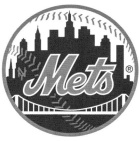

22

24

23

25

26

27

28
Chicago Cubs
시카고 컵스
USA

29
Florida Marlins
플로리다 마린스
USA

30
Houston Astros
휴스턴 애스트로스
USA

31
Atlanta Braves
애틀랜타 브레이브스
USA

32
San Diego Padres(New)
샌디에고 파드레스(新)
USA

33
San Diego Padres(Old)
샌디에고 파드레스(舊)
USA

34
Cincinnati Reds
신시네티 레즈
USA

35
Philadelphia Phillies
필라델피아 필리스
USA

28

29

30

31

32

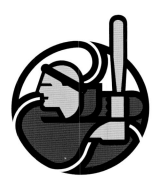

33

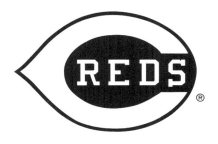

34

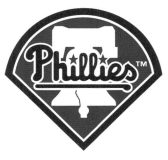

35

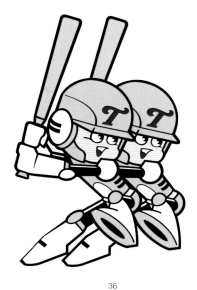

36

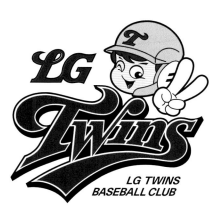

LG TWINS
BASEBALL CLUB

37-1

YOMIURI GIANTS

38

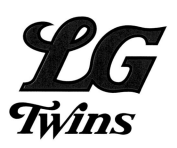

37-2

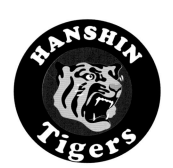

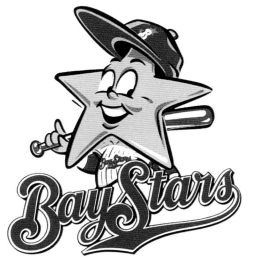

39

40

41

42
Wordmark for SsangBangWool
Raiders
쌍방울 레이더스 워드마크
Korea

43
Mascot for Hyundai Engineering &
Construction
현대건설 야구단 '피닉스' 마스코트
Korea

44
Blue Dragon Cup Baseball Game
청룡기 전국 중.고교 야구선수권
Korea

45
Mascot for Samsung Lions
삼성라이온즈 마스코트
Korea

42

43

44

45

46

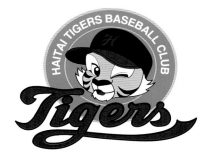

47

46
Samsung Lions
삼성라이온즈
Korea

47
Haitai Tigers Baseball Club
해태타이거즈야구단
Korea

48
Yakult Swallows
야쿠르트 스왈로즈
Japan

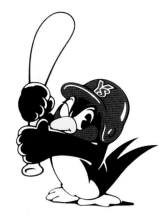

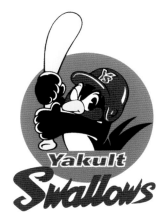

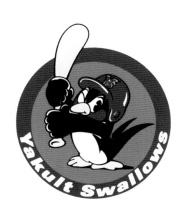

48

49

50

51

52

49
Hanhwa Eagles
한화 이글스
Korea

50
Chunichi Dragons
주니치 드래곤즈
Japan

51
Mascot for Hanhwa Eagles
한화 이글스 마스코트
Korea

52
Hiroshima Carf
히로시마 카프
Japan

53
South Florida Big League Baseball, Inc.
사우스 플로리다 리그
USA

54
Mascot for Hyundai Unicorns
현대유니콘스 마스코트
Korea

55
Hyundai Unicorns
현대 유니콘스
Korea

56-1, 2, 3
Doosan Professional Baseball Club
두산 프로야구단
Korea

53

54

55

56-1

56-2

56-3

57
Wordmark for Orix Baseball Club
'Blue Wave'
오릭스 블루웨이브 워드마크
Japan

58
Mascot for Orix Baseball Club 'Blue
Wave'
오릭스 블루웨이브 마스코트
Japan

59
Mascot for SsangBangWool Raiders
쌍방울 레이더스 마스코트
Korea

60
Emblem for Taiwan Major League
Professional Baseball
타이완 메이저 리그 엠블럼
Taiwan

61
Mascot for Taiwan Major League
Professional Baseball
타이완 메이저 리그 마스코트
Taiwan

62
Osaka Dome
오사카 돔·야구장
Japan

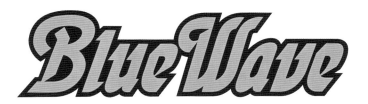

57

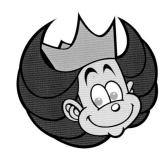

58

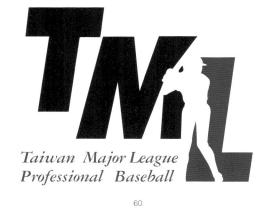

60

59

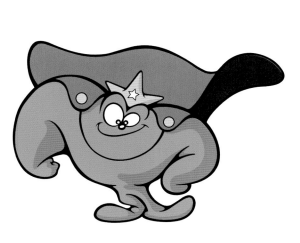

61

62

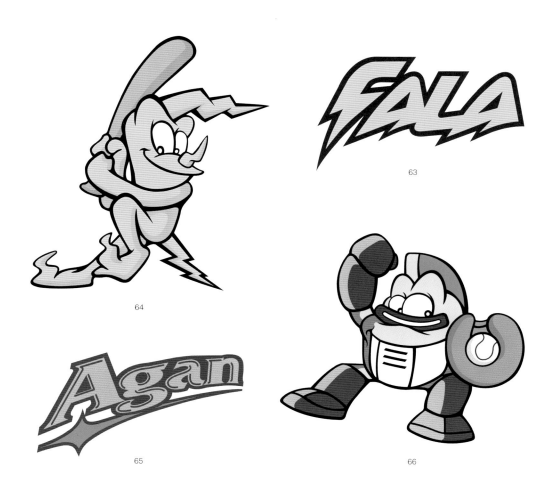

64

63

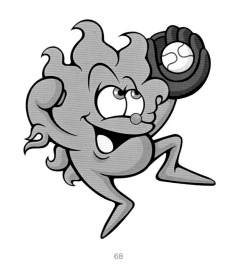

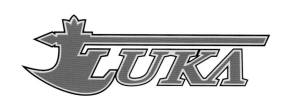

65

66

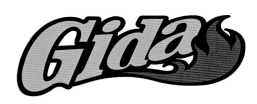

67

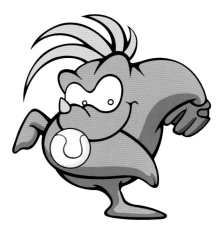

68

69

70

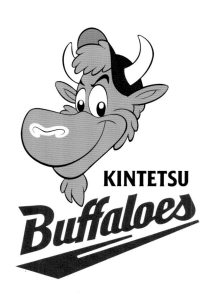

71

72
Worldcup Italia '90
이탈리아 월드컵 '90
Italy

73
WorldCup USA '94
미국 월드컵 '94
USA

74
WorldCup France '98
프랑스 월드컵 '98
France

75
Mascot for WorldCup France '98
'98 프랑스 월드컵 마스코트
France

72

73

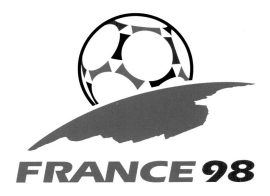

74

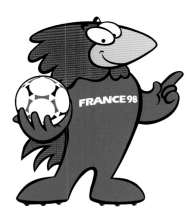

75

76
WorldCup Korea, Japan '2002(Korea, Japan)

77

78

UEFA
EURO
2000

79

KOREAN LEAGUE

80

©AFC

Asian Super Cup

81

82

LEBANON 2000
ASIANCUP

83

CLEATS & CLEAVAGE

SOCCER FACTORY

84

©AFC

Asian Club Championship

85

77
'98 Korean League
'98 한국프로축구 리그
Korea

78
Mascot for UEFA Euro 2000
유럽연합 리그 마스코트
Europe

79
Emblem UEFA Euro 2000
유럽연합 리그 엠블럼
Europe

80
Korean League
코리안 리그

81
Asian Super Cup
아시안 수퍼컵
Japan

82
Bundesliga
분데스리가
Germany

83
Lebanon 2000 Asian Cup
레바논 2000 아시안 컵
Lebanon

84
Cleats & Cleavage Soccer Factory
크리츠 앤 크리비치 사커 팩토리
USA

85
Asian Club Championship
아시안 클럽 챔피언쉽
Japan

86
De Strasbourg
더 스타스 부르그
France

87
Ajax Amsterdam
암스테르담 아젝스
Netherlands

88
Chun Nam Dragons Professional
Soccer Club
전남드레곤즈 축구클럽
Korea

89
Inter Milan
인터밀란
Italy

90
F.C. Girondins De Bordeaux
France

91
F.C. Gütersloh
Germany

92
Paris Saint Germain
파리 세인트 게르만
France

93
Vagabonds
배거본드즈
USA

94
LG Cheetahs
엘지 치타스
Korea

95
Mascot for LG Cheetahs
엘지 치타스 마스코트
Korea

86

87

88

89

90

91

93

92

94

95

96

97

98

99

100

101

102

103

104

105

106

96
FC.ST.Pauli
Germany

97
Paris S.G.
파리 S.G.
France

98
F.C. Hansa
F.C. 한사
Germany

99
F.C. De Martigues
F.C. 마티거스
France

100
Samsung Bluewings
삼성 블루윙즈
Korea

101
FCNA
France

102
Racing Club De Lens
France

103
TFC
France

104
F.C. Arsenal
F.C. 아시널
Great Britain

105
England F.C.
England

106
A.J. Auxerre
France

107
Chunbuk Dinos Football Club
전북 다이노스 프로축구단
Korea

108
Montpellier Herault
France

109
F.C. Lorient
France

110
Le Mans
France

111
S.C.B.
France

112
VfB Stuttgart
VfB 스투트가르트
Germany

113
SK Puchon Football Club
부천 에스케이 축구단
Korea

114
Stade Rennais Football Club
France

115
Asian Football Confederation
아시아 축구연맹
Asia

107

108

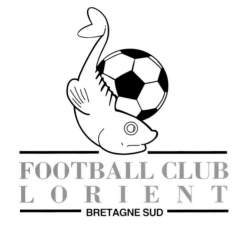

109

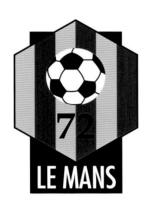

110

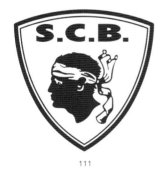

111

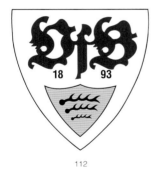

112

113

114

115

116

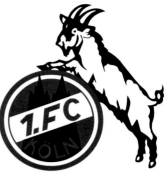

117

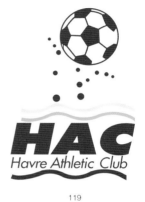

119

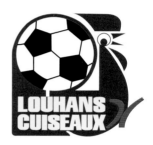

118

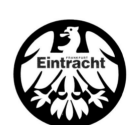

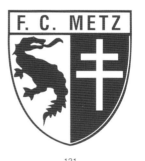

121

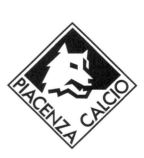

120

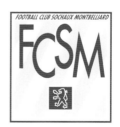

123

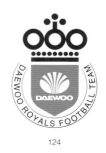

124

125

126

116
Hyundai Horang-i Football Club
현대 호랑이축구단
Korea

117
F.C. Koln
F.C. 쾰른
Germany

118
Louhas Cuiseaux
France

119
Havre Athletic Club
하버 체육클럽
France

120
Frankfurt Eintracht
프랑크푸르트 인터렉츠
Germany

121
F.C. Metz
F.C. 메츠
France

122
Piacenza Calcio
Italy

123
F.C. Sochaux Montbelliard
France

124
Daewoo Royals Football Team
대우로얄즈
Korea

125
Droit Au But
France

126
TSV 1860 Munchen
TSV 1860 뮌헨
Germany

129

128

132

133

134

136

135

128
Emblem for Avispa Fukuoka
후쿠오카 아비스파 엠블럼
Japan

129
Mascot for Avispa Fukuoka
후쿠오카 아비스파 마스코트
Japan

130
Wordmark for Avispa Fukuoka
후쿠오카 아비스파 워드마크
Japan

131
Emblem for Bellmare Hiratsuka
히라츠카 벨메르 엠블럼
Japan

132
Mascot for Bellmare Hiratsuka
히라츠카 벨메르 마스코트
Japan

133
Wordmark for Bellmare Hiratsuka
히라츠카 벨메르 워드마크
Japan

134
Emblem for Cerezo Osaka
오사카 세레조 엠블럼
Japan

135
Mascot for Cerezo Osaka
오사카 세레조 마스코트
Japan

136
Wordmark for Cerezo Osaka
오사카 세레조 워드마크
Japan

137
Wordmark for Red Diamonds Urawa
우라와 레드 다이아몬즈 워드마크
Japan

138
Emblem for Red Diamonds Urawa
우라와 레드 다이아몬즈 엠블럼
Japan

139
Mascot for Red Diamonds Urawa
우라와 레드 다이아몬즈 마스코트
Japan

140
Emblem for Jef United
제프 유나이티드 엠블럼
Japan

141
Mascot for Jef United
제프 유나이티드 마스코트
Japan

142
Wordmark for Jef United
제프 유나이티드 워드마크
Japan

143
Emblem for Consadole Sapporo
삿포로 콘사돌 엠블럼
Japan

144
Wordmark for Consadole Sapporo
삿포로 콘사돌 워드마크
Japan

145
Mascot for Consadole Sapporo
삿포로 콘사돌 마스코트
Japan

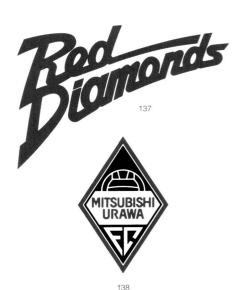

137

138

139

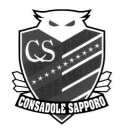

140

141

JEF UNITED

142

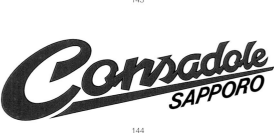

143

144

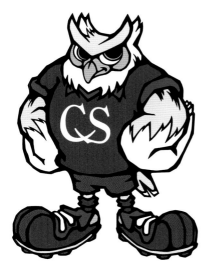

145

147

150

153

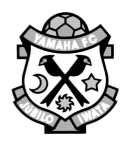

146

148

149

151

152

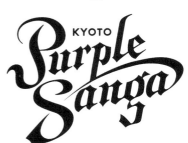

154

146
Emblem for Jubilo Iwata
이와타 주비로 엠블럼
Japan

147
Mascot for Jubilo Iwata
이와타 주비로 마스코트
Japan

148
Wordmark for Jubilo Iwata
이와타 주비로 워드마크
Japan

149
Emblem for Kashima Antlers
카시마 안틀러스 엠블럼
Japan

150
Mascot for Kashima Antlers
카시마 안틀러스 마스코트
Japan

151
Wordmark for Kashima Antlers
카시마 안틀러스 워드마크
Japan

152
Emblem for Kyoto Purple Sanga
교토 퍼플 산가 엠블럼
Japan

153
Mascot for Kyoto Purple Sanga
교토 퍼플 산가 마스코트
Japan

154
Wordmark for Kyoto Purple Sanga
교토 퍼플 산가 워드마크
Japan

155
Emblem for Kashiwa Reysol
카시와 레이솔 엠블럼
Japan

156
Wordmark for Kashiwa Reysol
카시와 레이솔 워드마크
Japan

157
Mascot for Kashiwa Reysol
카시와 레이솔 마스코트
Japan

158
Wordmark for Nagoya Grampus Eight
나고야 그램퍼스 에이트 워드마크
Japan

159
Emblem for Nagoya Grampus Eight
나고야 그램퍼스 에이트 엠블럼
Japan

160
Emblem for Panasonic Gamba Osaka
오사카 파나소닉 감바 엠블럼
Japan

161
Wordmark for Panasonic Gamba Osaka
오사카 파나소닉 감바 워드마크
Japan

162
Mascot for Panasonic Gamba Osaka
오사카 파나소닉 감바 마스코트
Japan

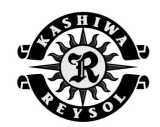

155

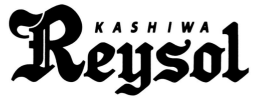

156

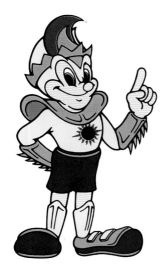

157

158

159

160

161

162

163

164

165

167

166

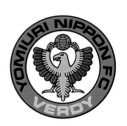

168

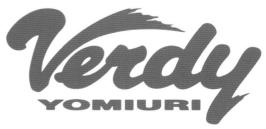

169

170

163
Wordmark for S-Pulse Shimizu
시미즈 에스 플러스 워드마크
Japan

164
Mascot for S-Pulse Shimizu
시미즈 에스 플러스 마스코트
Japan

165
Emblem for Sanfrecce Hiroshima
히로시마 산프레스 엠블럼
Japan

166
Wordmark for Sanfrecce Hiroshima
히로시마 산프레스 워드마크
Japan

167
Mascot for Sanfrecce Hiroshima
히로시마 산프레스 마스코트
Japan

168
Emblem for Yomiuri Verdy
요미우리 버디 엠블럼
Japan

169
Mascot for Yomiuri Verdy
요미우리 버디 마스코트
Japan

170
Wordmark for Yomiuri Verdy
요미우리 버디 워드마크
Japan

171
Emblem for Yokohama Marinos
요코하마 마리노스 엠블럼
Japan

172
Wordmark for Yokohama Marinos
요코하마 마리노스 워드마크
Japan

173
Mascot for Yokohama Marinos
요코하마 마리노스 마스코트
Japan

174
Emblem for Yokohama Flugels
요코하마 플뤼겔스 엠블럼
Japan

175
Wordmark for Yokchama Flugels
요코하마 플뤼겔스 워드마크
Japan

176
Mascot for Yokohama Flugels
요코하마 플뤼겔스 마스코트
Japan

177
Emblem for Vissel Kobe
고베 비셀 엠블럼
Japan

178
Wordmark for Vissel Kobe
고베 비셀 워드마크
Japan

179
Mascot for Vissel Kobe
고베 비셀 마스코트
Japan

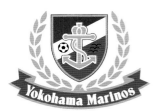

171

173

172

174

176

177

179

VISSEL KOBE

178

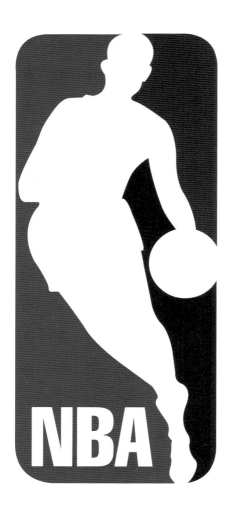

180
NBA(USA)

181
Utah Jazz
유타 재즈
USA

182
Boston Celtics
보스톤 셀틱스
USA

183
Portland Trail Blazers
포틀랜드 트레일 블레이져스
USA

184
Milwaukee Bucks
밀워키 벅스
USA

185
Sacramento Kings
새크러멘토우 킹스
USA

186
New York Knicks
뉴욕닉스
USA

187
Indiana Pacers
인디아나 페이서스
USA

188
Orlando Magic
올랜도 매직
USA

189
Cleveland Cavaliers
클리블랜드 캐벌리어스
USA

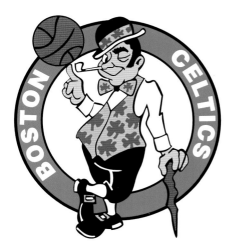

182

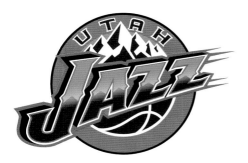

181

184

185

186

187

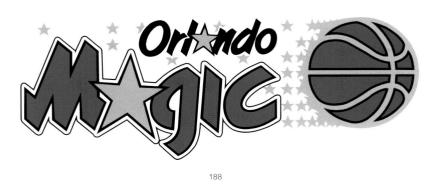

188

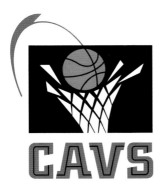

189

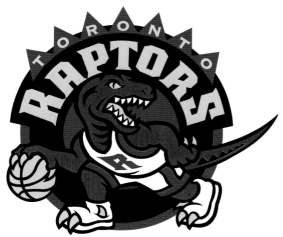

190

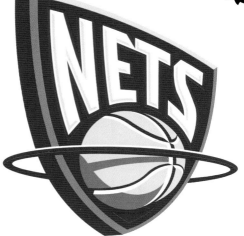

191

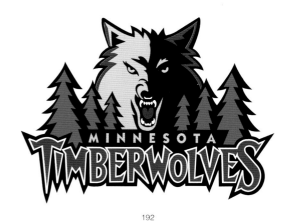

192

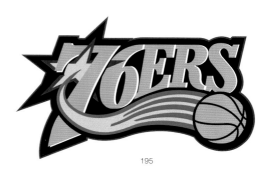

195

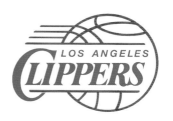

193

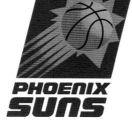

194

196

197

190
Toronto Raptors
토론토 랩토스
USA

191
New Jersey Nets
뉴져지 네츠
USA

192
Minnesota Timberwolves
미네소타 팀버울브스
USA

193
Los Angeles Clippers
로스엔젤레스 클립퍼스
USA

194
Phoenix Suns
휘닉스 썬즈
USA

195
Philadelphia 76ers
필라델피아 세븐티식서스
USA

196
Vancouver Grizzlies
벤쿠버 그리즐리스
USA

197
Atlanta Hawks
애틀랜다 호크스
USA

198
Inchon Daewoo Zeus
인천 대우 제우스
Korea

199
Mascot for Samsung Thunders
Basketball Club
수원 삼성 썬더즈 농구단 마스코트
Korea

200
Chicago Bulls
시카고 불스
USA

201
Denver Nuggets
덴버 너깃츠
USA

202
San Antonio Spars
샌 안토니오 스파스
USA

203
Mascot for SBS Stars
SBS 스타즈 프로농구단 마스코트
Korea

199

198

200

201

202

203

41

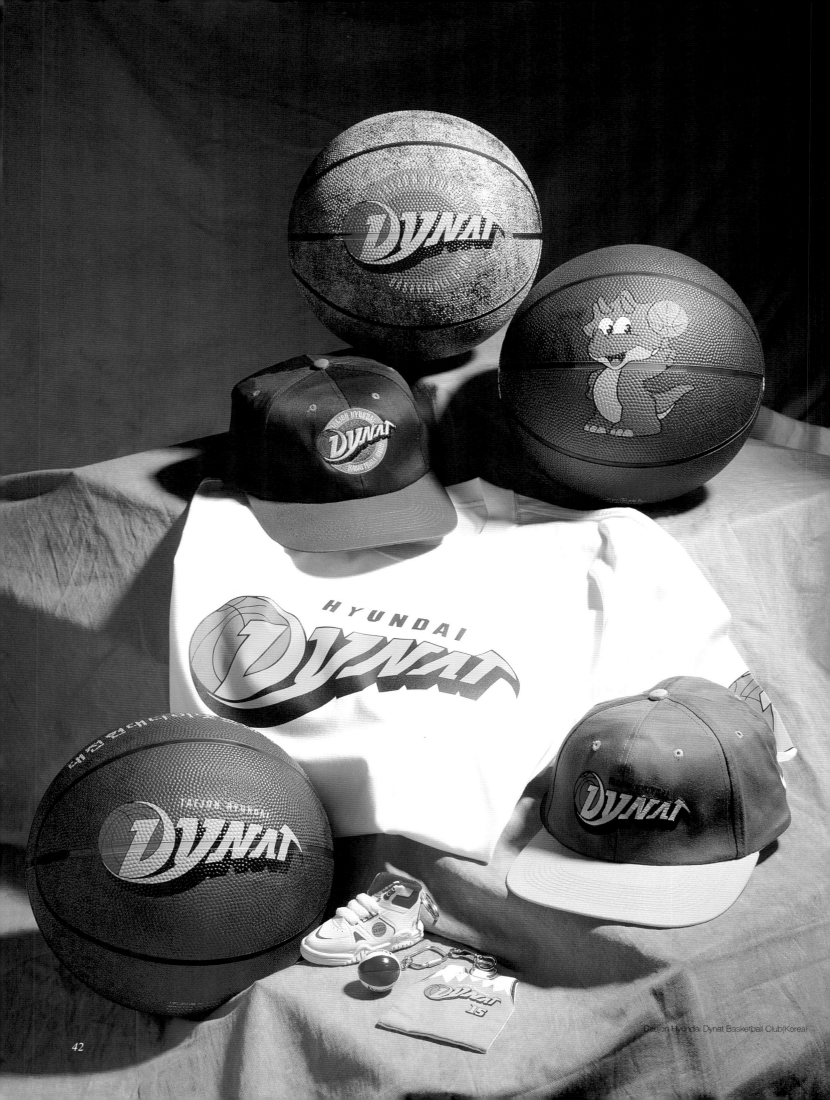

Daejon Hyundai Dynat Basketball Club(Korea)

204
Suwon Samsung Thunders
Basketball Club
수원삼성 썬더스 엠블렘
Korea

205
Daejon Hyundai Dynat Basketball
Club
대전현대 다이냇 농구단
Korea

206
Korean Basketball League
KBL한국프로농구리그
Korea

207
SK Knights Basketball Club
SK 나이츠 프로농구단
Korea

208
Mascot for SK Knights
SK 나이츠 마스코트
Korea

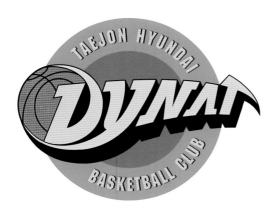

205

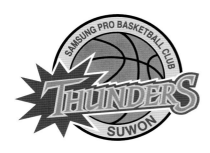

204

206

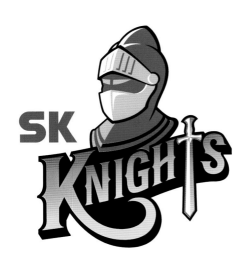

207

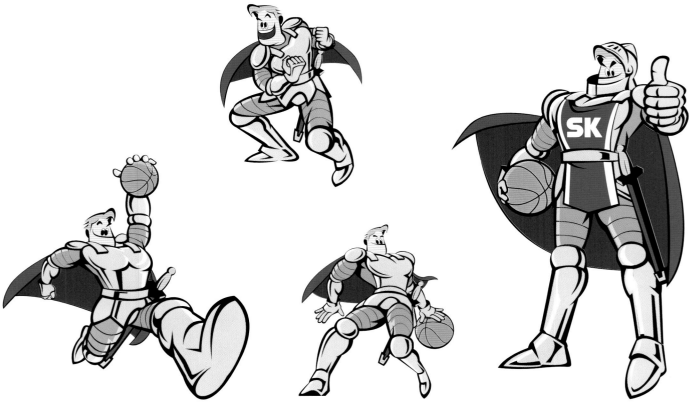

208

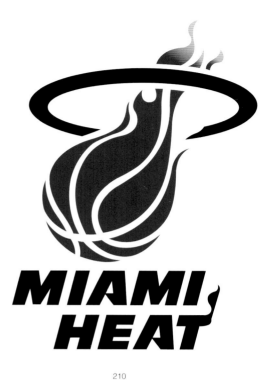

MIAMI HEAT

210

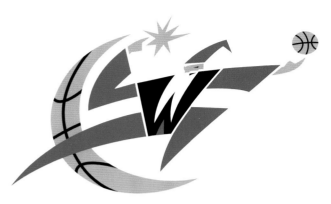

209

DALLAS MAVERICKS®

211

213

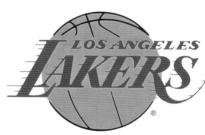

LOS ANGELES LAKERS

212

WARRIORS

214

215

CHARLOTTE HORNETS

216

SEATTLE SONICS

217

209
Washington Wizards
워싱턴 위저즈
USA

210
Miami Heat
마이애미 히트
USA

211
Dallas Mavericks
달라스 마베릭스
USA

212
Los Angeles Lakers
로스엔젤스 레이커스
USA

213
Mascot for Naray Bluebird
나래블루버드 마스코트
Korea

214
Golden State Warriors
골든 스테이트 워리어스
USA

215
Detroit Pistons
디트로이트 피스톤스
USA

216
Charlotte Hornets
샬롯 호넷츠
USA

217
Seattle Super Sonics
시애틀 수퍼소닉스
USA

218
Spanish Basket Federation
스페인 농구연합
Spain

219
Nike & Coca Cola 3on3 Street
Basketball
나이키 3대3 길거리농구대회
Korea

220
Shinsegae Coolcat Women's
Basketball Team
신세계 쿨켓 여자 농구단
Korea

221
Mascot for Shinsegae Coolcat
신세계쿨켓 마스코트
Korea

222-1, 2, 3
Pusan Kia Enterprise Basketball Club
부산기아 엔터프라이즈 농구단
Korea

218

219

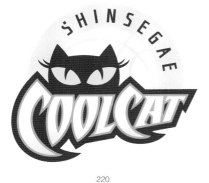

220

221

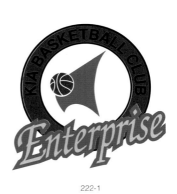

222-1

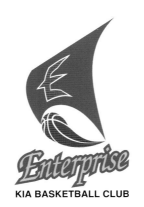

222-2

222-3

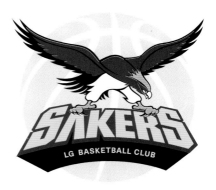

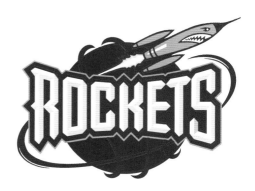

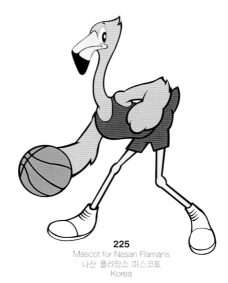

223
LG Sakers Basketball Club
LG세이커스 프로농구단
Korea

224
Houston Rockets
휴스톤 로켓츠
USA

225
Mascot for Nasan Flamans
나산 플라망스 마스코트
Korea

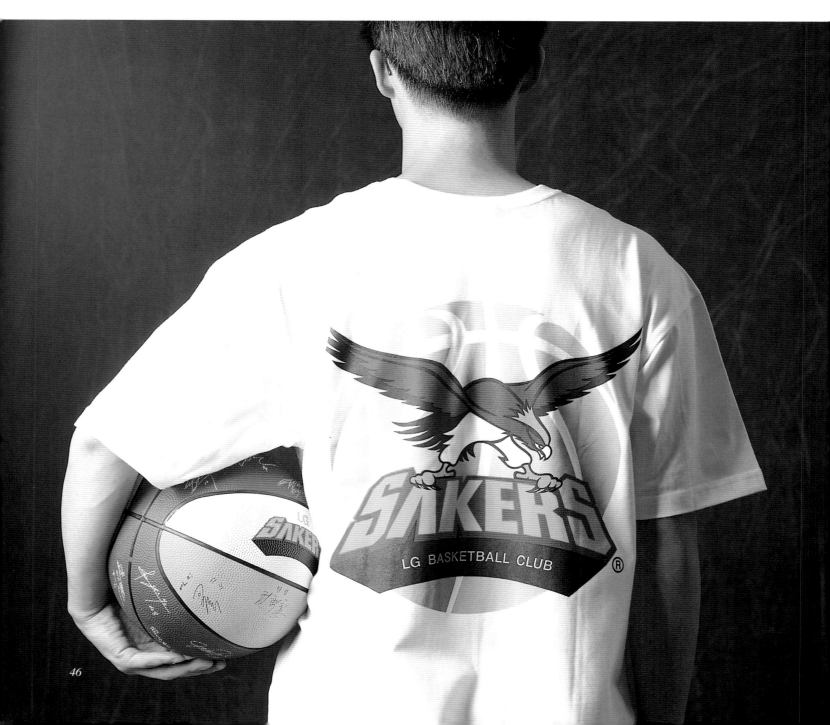

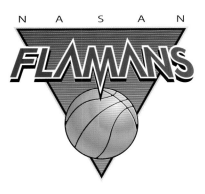

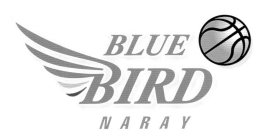

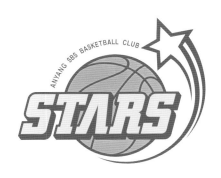

226
Emblem for Nasan Flamans Basketball Team
나산 플라망스 농구단 엠블럼
Korea

227
Naray Bluebird Pro Basketball Team
나래 블루버드
Korea

228
SBS Stars Basketball Club
SBS 스타즈 프로농구단
Korea

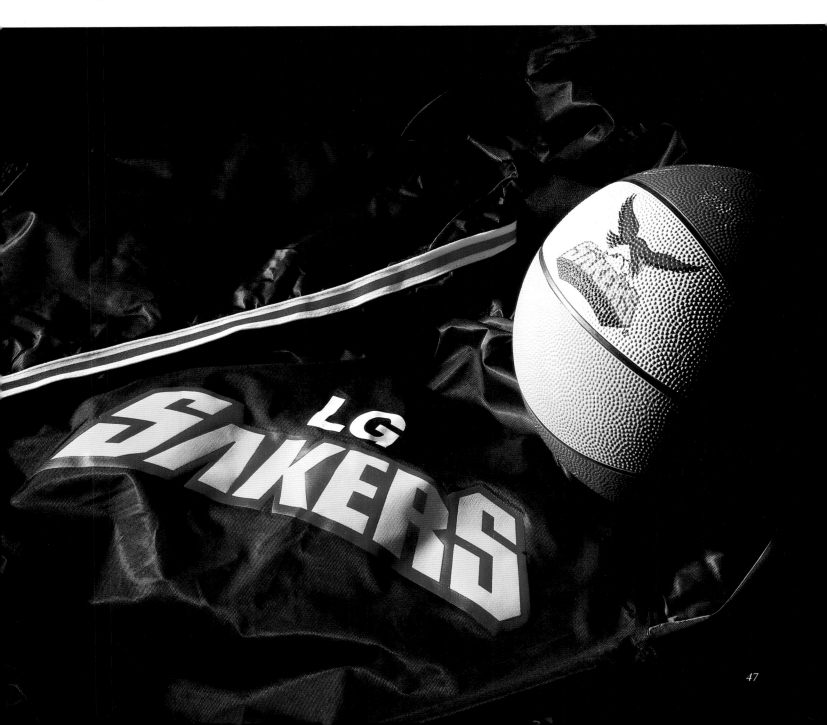

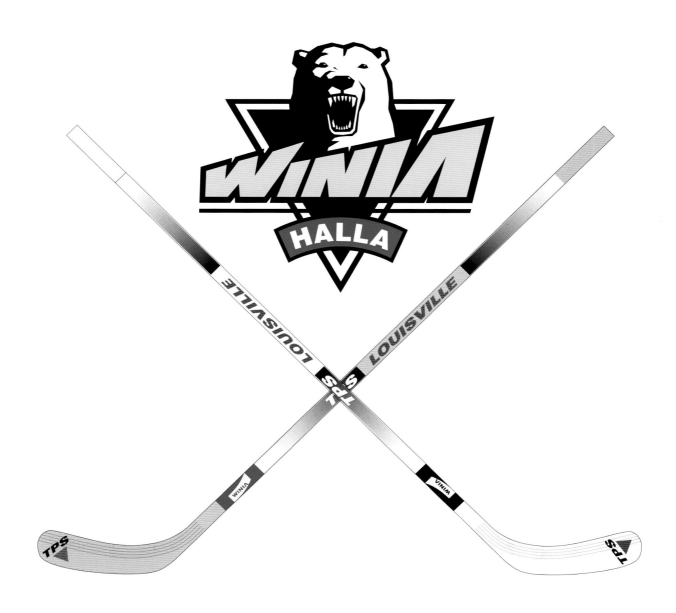

229
Halla Winia(Korea)

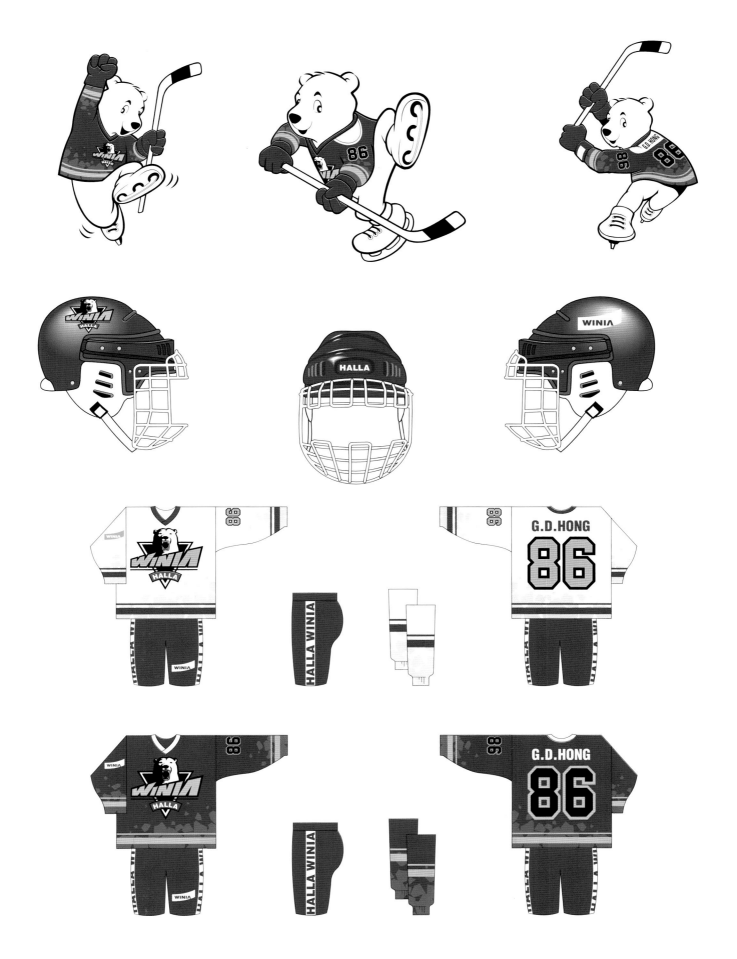

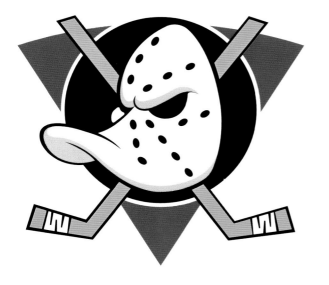

230

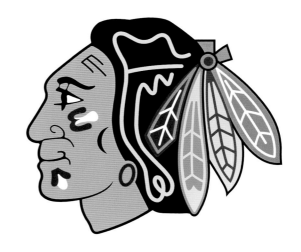

231

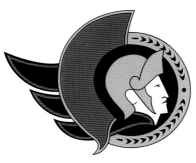

233

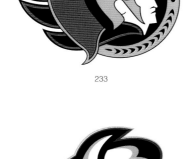

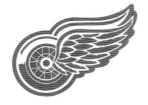

232

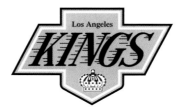

234

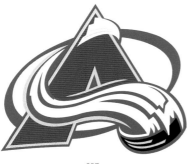

235

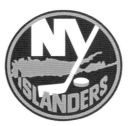

236

237

238

230
Anaheim Mighty Ducks
애너하임 마이티 덕스
USA

231
Chicago Blackhawks
시카고 블랙호크스
USA

232
Detroit Red Wings
디트로이트 레드 윙즈
USA

233
Ottawa Senators
오타와 세너터스
USA

234
Los Angeles Kings
로스 앤젤레스 킹스
USA

235
Buffalo Sabres
버팔로 사브레스
USA

236
New York Islanders
뉴욕 아일랜더스
USA

237
Colorado Avalanche
콜로라도 애벌랜치
USA

238
New York Rangers
뉴욕 레인저스
USA

239

240

239
Dallas Stars
달라스 스타즈
USA

240
Phoenix Coyotes
피닉스 코이요테스
USA

241
San Jose Sharks
산호세 샥스
USA

242
Florida Panthers
플로리다 팬더스
USA

243
Carolina Hurricanes
캐롤리나 헤리케인스
USA

244
Vancouver Canucks
밴쿠버 캐넉스
USA

245
Philadelphia Flyers
필라델피아 플라이어스
USA

246
New Jersey Devils
뉴저지 데빌즈
USA

247
Edmonton Oilers
에드몬턴 오일러스
USA

248
Kookmin Life Futures Ice Hockey
Club
Korea

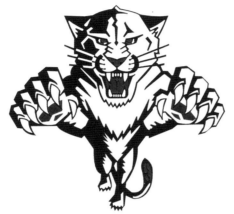

242

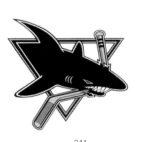

241

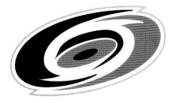

243

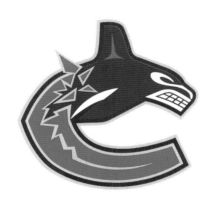

244

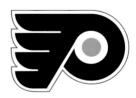

245

246

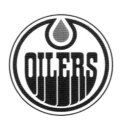

247

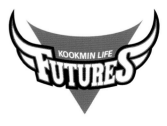

248

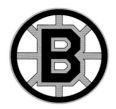

249

251

252

254

256

257

250

253

255

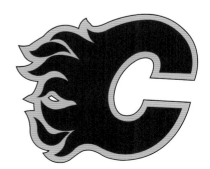

258

249
Boston Bruins
보스톤 브루인스
USA

250
Toronto Maple Leafs
토론토 메이플 립스
USA

251
Tampa Bay Lightning
탐파베이 라이트닝
USA

252
National Hockey League
내셔널 하키리그
USA

253
Washington Capitals
워싱턴 캐피탈즈
USA

254
St. Louis Blues
세인트 루이스 블루스
USA

255
Pittsburgh Penguins
피츠버그 펭귄스
USA

256
Ames Minor Hockey Association
아메스 마이너 하키협회
USA

257
Montreal Canadians
몬트리얼 캐나디언스
USA

258
Calcary Flames
캘거리 플레임스
USA

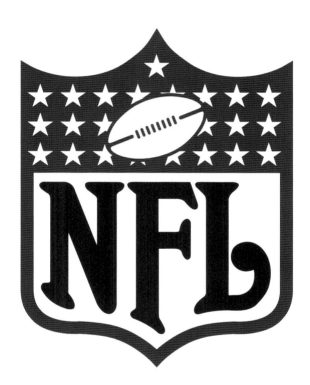

259
National Footbool League(USA)

260

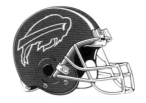

261

262

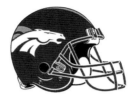

263

264

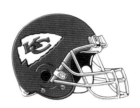

265

266

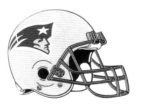

267

268

269

270

271

272

273

260
Baltimore Ravens

261
Buffalo Bills

262
Cincinnati Bengals

263
Denver Broncos

264
Indianapolis Colts

265
Kansas City Chiefs

266
Miami Dolphins

267
New England Patriots

268
New York Jets

269
Oakland Raiders

270
Seattle Seahawks

271
Pittsburgh Steelers

272
San Diego Chargers

273
Tennessee Oilers

274
Arizona Cardinals

275
Atlanta Falcons

276
Carolina Panthers

277
Chicago Bears

278
Dallas Cowboys

279
Detroit Lions

280
Washington Redskins

281
Green Bay Packers

282
Minesota Vikings

283
Tampa Bay Buccaneers

284
New Orleans Saints

285
New York Giants

286
St. Louis Rams

287
Philadelphia Eagles

288
San Francisco 49ers

274

275

276

277

278

279

280

281

282

283

284

285

286

287

288

290
Ko Olina-Golf Club
CL:PPH/Pan Pacific Hoteliers
코 올리나 골프클럽
USA

291
Hwasan Country Club
화산 컨트리클럽
Korea

292
Chungmun Beach Golf Club
제주중문 비취 골프클럽
Korea

293
Rexfield Country Club
렉스필드 컨트리클럽
Korea

294
Ureshino Onsen Highland Golf Club
우레시노 온센 골프클럽
Japan

295
ChinJu Country Club
진주 컨트리클럽
Korea

296
Dynasty Country Club
다이너스티 컨트리클럽
Korea

297
Seowon Valley Golf Club
서원밸리 골프클럽
Korea

298
The Asiana Country Club
아시아나 컨트리클럽
Korea

299
Club 700
클럽 700
Korea

290

291

292

294

293

295

296

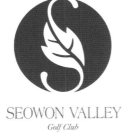

297

298

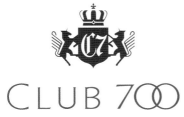

299

300

301

302

303

304

305

306

307

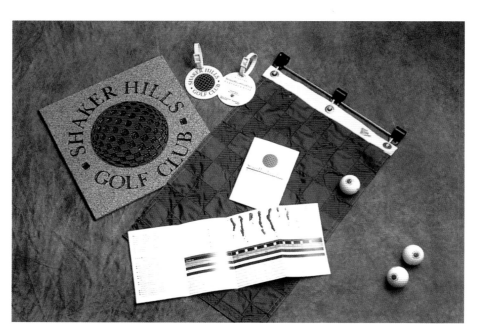

300
Rifu Golf Club
리푸 골프클럽
Japan

301
EHS Country Club
은화삼 컨트리클럽
Korea

302
Kangchon Country Club
강촌 컨트리클럽
Korea

303
Taikoyama Country Club
타이코야마 컨트리클럽
Japan

304
Long Lake Hill Country Club
롱레이크힐 컨트리클럽
USA

305
Taein Country Club
태인 컨트리클럽
Korea

306
Tomakomai Country Club Brooks
Course
토마코마이 컨트리클럽 브룩스 코스
Japan

307
Richard O. Howe/Crystal Downs
Country Club
크리스탈 다운즈 컨트리 클럽
USA

Oak Valley(Korea)

308
Shaker Hills Golf Club(USA)

309
Tapawingo National Golf Club
타파윙 골프클럽
USA

310
Lowes Island Club
로웨스 아일랜드 클럽
USA

311
Conceptual
컨셉츄얼
Spain

312
Crest Hills Golf Club
크레스트 힐즈 컨트리클럽
Japan

313
Uksung Grand Country Club
욱성 그랜드 컨트리 클럽
Japan

314
Nikko Kirifuri Country Club
니코 키리퓨리 컨트리클럽
Japan

315
Qualchan Golf Course
괄찬 골프코스
USA

316
Authent Golf Club
오쎈트 골프클럽
Japan

317
Loomis Trail Golf Club
루미스 트레일 골프클럽
USA

318
Titleist-Golf Club Division
타이틀리스트
USA

319
Groff's Farm Golf Club
그로프즈 팜 골프클럽
USA

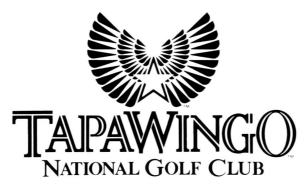

309

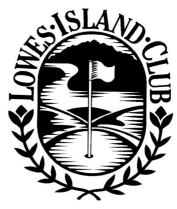

310

311

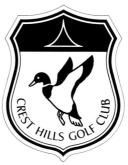

312

313

314

315

316

317

318

319

320

321

322

323

324

325

326
Tipness Golf Club Par's
CL:Tipness Ltd.
티프네스 골프클럽
Japan

327
Yangsan Adonis Country Club
양산 아도니스 컨트리클럽
Korea

328
Konjiam Country Club
곤지암 컨트리클럽
Korea

329
Eventail Golf Club
이벤테일 골프클럽
Japan

330
Nantucket Golf Club
넌턱키트 골프클럽
USA

331
British Garden Golf Club
브리티쉬 가든 골프클럽
Japan

332
WooJung Hills Country Club
우정 힐즈 컨트리클럽
Korea

333
Segovia Golf Club Chiyoda
세고비아 골프클럽 지요다
Japan

326

327

329

328

331

330

332

333

334

335

337

339

340

336

338

334
Sapporo Tokyu Open Golf
삿포로 도큐 오픈 골프대회
Japan

335
Rose Ladies Open Golf
Championship
제일모직 로즈 오픈 여자 골프대회
Korea

336
U.S. Open Golf Championship
유에스 오픈 골프 챔피언쉽
USA

337
Hyundai Motor Golf Championship
현대자동차 골프대회
Korea

338
The 42nd Lance Field KPGA
Championship
42회 랭스필드컵 골프대회
Korea

339
PGA Tour
피지에이 투어
USA

340
Samsung Masters Championship
삼성마스터즈 골프대회
Korea

341
Forest National Ice Hockey Club
포레스트 네셔널 아이스하키 클럽
USA

342
Gang of Seven-Bicycle Racing Team
갱 오브 세븐-사이클팀
USA

343
Sansringham Hockey Club
Melbourne

344
The league of Japan Tekondo
일본태권도 리그
Japan

345
Eight is Enough Volleyball Team
USA

346
Canadian Cycling Association
캐나다 사이클 협회
Canada

347
Cazenovia Rowing Club
카재노비아 로윙 클럽
USA

348
Team Mad Dog
머독 모터사이클팀
USA

349
San Diego Hiking Club-Back Packing
& Hiking Club
샌디에고 하이킹클럽
USA

350
Ektelkon-Sponsors of Olympic
Racketball Team
엑텔콘-올림픽 라켓볼팀 스폰서
USA

351
Blind Mule Sports Car Racing Team
블라인드 뮬 스포츠카 레이싱팀
USA

341

343

344

347

349

342

345

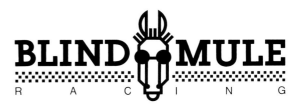

346

348

351

350

65

352

353

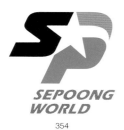

354

356

355

358

357

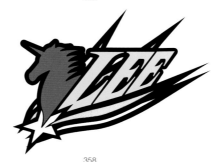

360

359

361

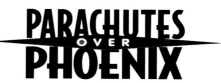

362

363

352
Japan Volleyball Association
일본배구협회
Japan

353
America's Cup '88
'88 아메리카 컵 요트경기 대회
USA

354
Sepoong World
세풍월드·자동차경기장
Korea

355
Korea Wu-shu Federation
대한우슈연합회
Korea

356
Bison Kimura
비손 키무라·레스링팀
Japan

357
Armed Forces Athletic Team
국군체육부대·상무
Korea

358
Lee
리·레스링팀
Japan

359
Korea Ski Association
대한스키협회
Korea

360
Chikako Shiratotri
치카고 시라토리·레스링팀
Japan

361
U.S.Canoe and Kayak Team
미국 카누, 카약팀
USA

362
Parachutes over Phoenix Desert
Skydiving Center
스카이 다이빙센터
USA

363
Lecaf Ski School
르까프 스키 스쿨
Korea

Spring Racing Carnival

365 366

367

368

369
TCK
Japan

370
British Showjumping Association
영국 마장마술협회
United Kingdom

371
JRA
일본 중앙경마회
Japan

372
Mercedes Benz Cup Horses Racing
벤츠컵 경마대회
United Kingdom

373
Samsung Nations Cup Horses Racing
삼성 네이션스컵 국제 승마대회
Korea

374
Korean Horse Affairs Association
한국마사회
Korea

375
Pik 'Pozarevc'
경마장
Yugoslavia

376
Greater Miami Valley Horse Show
-Equestrain Event
그레이터 마이애미 밸리 홀스 쇼
USA

377
Hammond Equestrian Center-Horse
Stables and training-Equestrin Center
해몬드 이퀘스트리언 센터
USA

378
Swiss Association of Jockeys-Racing
Association
스위스 마사회
Swiss

369

370

371

372

373

374

376

375

377

378

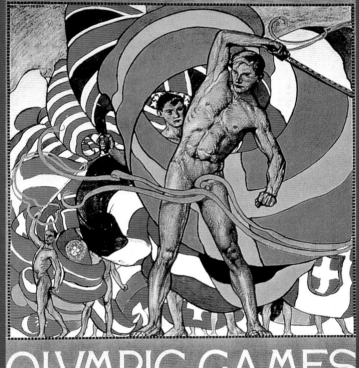

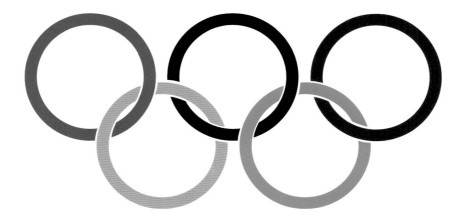

380
Five ring Olympic Emblem(France)

381

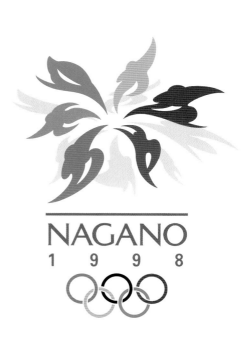

382

383

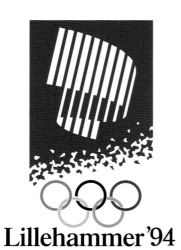

384

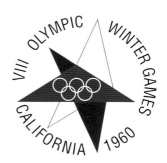

385

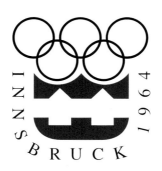

386

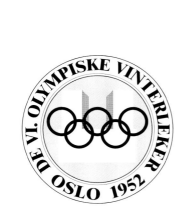

387

388
Montreal 1976
몬트리올 올림픽
Canada

389
Barcelona '92
바르셀로나올림픽
Spain

390
Mexico Olympics '68
'68 멕시코 올림픽
Mexico

391
Lake Placid '80
레이크 플래시드

392
Tokyo Olympic Games 1964
도쿄 올림픽
Japan

393
Munchen Olympics '72
뮌헨 올림픽
Germany

394
Moscow
모스크바 올림픽
U.S.S.R.

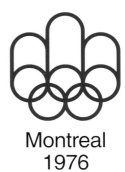

Montreal
1976

388

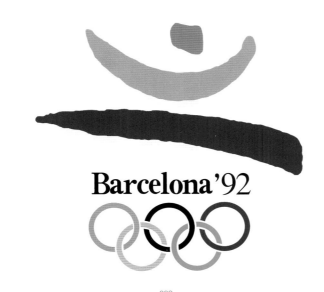

389

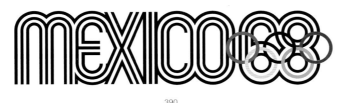

390

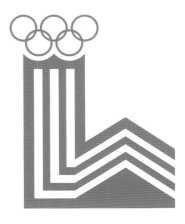

391

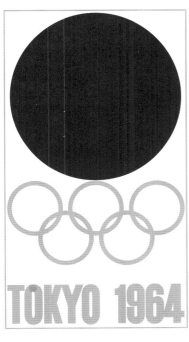

392

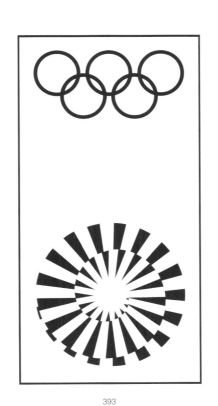

393

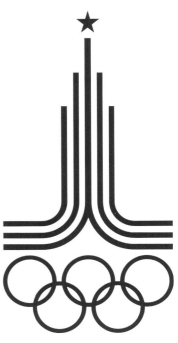

394

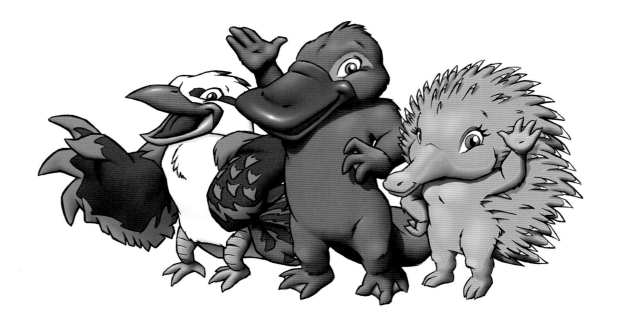

395

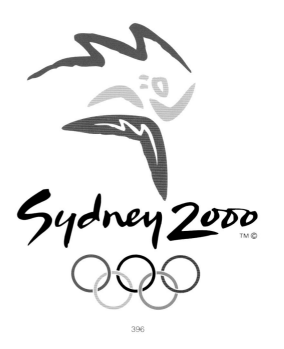

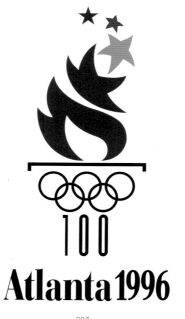

396

397

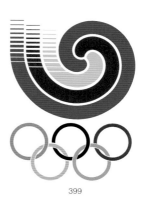

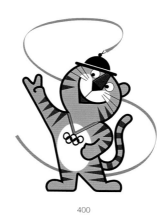

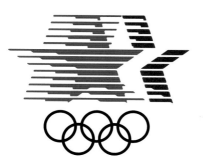

399

400

401

402
Albertville '92
알베르빌 동계올림픽

403
Sapporo '72
'72년삿포로 동계올림픽
Japan

404
France Grenoble Winter Olympic
그레노빌 동계올림픽
France

405
World University Summer Games '95
Fukuoka
'95 후쿠오카 유니버시아드
Japan

406
Winter Universiades '97 Muju
'97 무주 유니버시아드 엠블럼
Korea

407
Special Olympics World Games
Connecticut-Handicapped Olympic
Games
세계 장애자 올림픽
USA

408
Winter Universiades '97 Muju
'97 무주 유니버시아드 엠블럼
Korea

409
East Asian Games '97 Pusan
1997 부산 동아시안게임
Korea

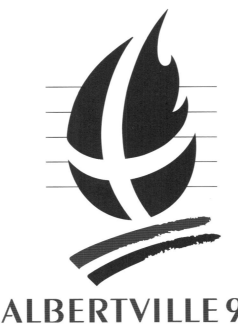

402

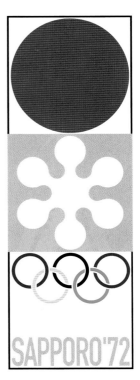

403

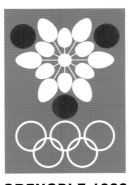

GRENOBLE 1968

404

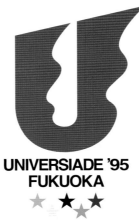

405

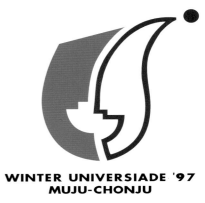

406

407

408

409

**13th
ASIAN GAMES
BANGKOK 1998**

© 1995 BAGOC (Sports Authority of Thailand)

411

ENER ONWARD

OLYMPIC COUNCIL OF ASIA

Founded 1982

410

CHAI-YO

© 1996 BAGOC (Sports Authority of Thailand)

412

410
Olympic Council of Asia
아시아 올림픽 위원회

411
Bangkok Asian Games
방콕 아시안 게임 엠블렘
Thailand

412
Mascot for Bangkok Asian Games
방콕 아시안 게임 마스코트
Thailand

413
'99 Asian Winter Game
1999년 제4회 동계아시아경기
Korea

414
'96 Harbin Asian Game
96' 하얼빈 동계 아시안 게임
China

415
Hiroshima Asian Game
히로시마 아시안 게임
Japan

416
Peking Asian Game
11회 북경아시안게임
China

417
The 10th Asian Game in seoul
10회 서울 아시안 게임
Korea

418
New Delri Asian Game
뉴델리 아시안 게임
India

413

414

415

416

417

418

419
Fit@Sun-Fitness Center
피트엣선
USA

420
Wellbe Sports Club
웰비 스포츠 클럽
Korea

421
Kolon Sporex
코오롱 스포렉스
Korea

422
Daewoo Green Sports Center
대우그린스포츠센터
Korea

423
Sigma Sports Club
CL:Halla Co. Ltd.
시그마 스포츠클럽
Korea

424
Sportime
스포타임
Korea

425
Swedish Alpin Ski Pool
스웨덴 알파인 스키장
Sweden

426
Soraehill Members
서래힐멤버즈
Korea

419

420

KOLON SPOREX

421

GREEN SPORTS CENTER
대우그린스포츠센터

422

SIGMA Sports Club

423

424

425

426

427

428

429

430

431

432

433

434

435

427
Health Program
CL:Southern California Gas Co.,Ltd.
헬스 프로그램
USA

428
Prema Vikara-Yoga Center
프리마 비카라 요가센터
USA

429
Judy Freedman-Yoga Instructor
주디 프리드맨-요가교사
USA

430
Nippon Bowling Center
일본볼링센터
Japan

431
Towers Residence Association
타워즈 레지던스 협회
USA

432
Rhodes Club Fitness
로우드즈 체육관
USA

433
Dragon Bowling Center
드래곤 볼링센터
USA

434
Katsuyama Bowling Center
카쥬야마 볼링센터
Japans

435
Squash Club Milano
밀라노 스쿼시 클럽
Italy

436
Ski Dome Ssaws-Indoor Ski Slope
CL:Mitsui Real Estate Development
Co., Ltd.
사계절 실내스키장
Japan

437
Keter Health's Club
케트 헬스클럽
USA

438
LA Sports Council
LA 스포츠 카운실
USA

439
Twins
트윈스
USA

440
Tipness-Fitness Club
CL:Tipness Ltd.
팁니스
Japan

441
Fuji Sports Club
후지스포츠 클럽
Japan

442
Boston Ski & Sports Club
보스톤 스키 앤 스포츠 클럽
USA

443
Sirius Fitness Club
시리우스 체육관
USA

436

437

439

438

440

441

442

443

445

447

THE JIMMY STEWART

RELAY MARATHON

449

452

DONG-A
INTERNATIONAL
MARATHON RACE

444

4th. CHITOSE & JAL INTERNATIONAL
POPULAR MARATHON.

446

MARATONA
DE SÃO PAULO

448

M. T. L.
CYCLING FESTIVAL

451

453

444
Dong-A International Marathon Race
동아국제마라톤대회
Korea

445
1990 Boston Marathon Race
1990 보스톤국제마라톤대회
USA

446
4th Chitose & JAL International
Popular Marathon
제4회 치토스 앤 잘 국제 대중 마라톤
대회
Japan

447
Chunchan Ilbo Marathon Race
조선일보 춘천 국제 마라톤대회
Korea

448
Maratona De Sao Paulo
마라토나 디 상 파울로
Sao Paulo

449
The Jimmy Stewart Relay Marathon
USA

450
Dupont Procycling Champ
듀퐁 프로 사이클대회
USA

451
M. T. L. Cycling Festival
CL:Koukokumaru Inc.
M.T.L. 사이클 페스티발
Japan

452
1993 Asia Cup Skating Competitions
1993 아시아컵 스케이트 대회
Japan

453
Korea Volleyball Super League
한국 배구 슈퍼리그
Korea

454
Volley Ball
CL:Nippon Television Network
니폰 텔레비전배 배구대회
Japan

450

454

455
F1 Grand Prix Motor Race
Korea

456
Skaters Championships Cincinnati,
USA 1992
신시내티 스케이트 챔피언쉽
USA

457
Racquetball USA-Racquetball
Organization
USA

458
Konica Cup Asian Badminton
Invitation Championship
코니카컵 아시안 초청 베드민턴대회
Korea

459
Tennis Adventures-Sport Tours
테니스 어드벤쳐
USA

460
US Open Tennis Championship
유에스 오픈 테니스 챔피언쉽
USA

461
Coca Cola Ski Racing
코카콜라컵 스키대회
Japan

462
Norlanco Field Hockey
놀랜코 필드하키 대회
USA

463
Asia Woman's Hand Ball
Championship
아시아 여자핸드볼 선수권대회
Korea

456

458

455

457

459

460

461

462

463

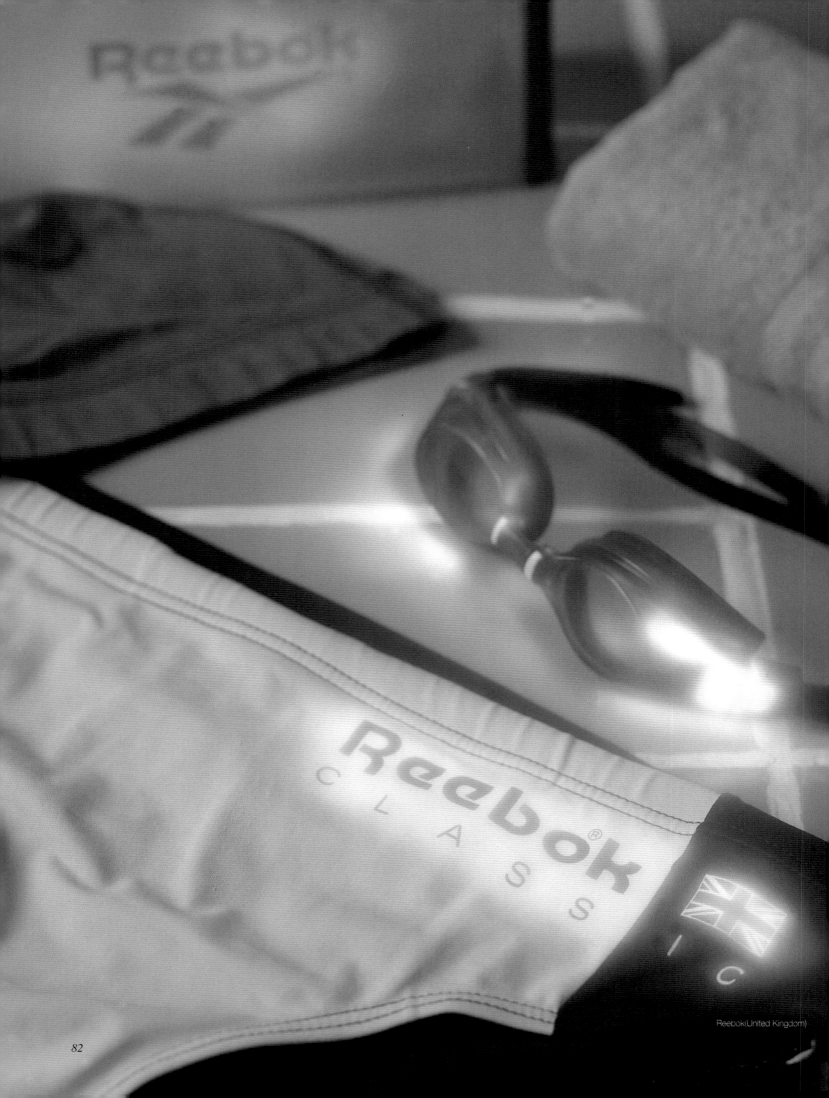

Reebok(United Kingdom)

464
Reebok
리북
United Kingdom

465
Nike
나이키
USA

466
Reebok
리북
United Kingdom

467
Fantom
팬텀
Korea

468
Elord
엘로드
Korea

469
Fine Corporation
화인·스포츠화(프로월드컵)
Korea

464

465

466

467

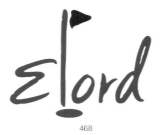

468

469

470

471

472

473

475

474

476

477

478

479

480

470
Pose
포즈
Korea

471
Head
헤드
USA

472
Minami Corporation
미나미 주식회사
Japan

473
Worldcup Jeje
월드컵 제제
Korea

474
Pro Worldcup
프로월드컵
Korea

475
Yard Stick
야드 스틱
Japan

476
Adidas Exin
아디다스 엑신
Germany

477
Spo's
CL:HwaSung Co., Ltd
스포츠
Korea

478
Naver Compromise
네이버 컴프로마이즈
USA

479
Adidas(New)
아디다스(新)
Germany

480
Adidas(Old)
아디다스(舊)
Germany

481
Activ
엑티브
Korea

482
Asics(Old)
아식스
Japan

483
Yonex
요넥스
USA

484
Lecaf
르까프
Korea

485
Mizuno
미즈노
Japan

486
Pro Specs
프로스펙스
Korea

487
Raisins Swimwear
레이젼스 수영복
USA

488
Nordica
노르디카
USA

489
Nassau
낫소
Japan

490
L.A. Gear
L.A. 기어
USA

491
Lynx-Golf Wear
랭스

492
AMF
USA

493
Puma
퓨마
Stockholm

481

482

483

484

485

486

487

488

489

490

491

492

493

494

495

497

496

498

499

500

TUSA

501

502

503

504

AQUAZ

505

 Underwater Kinetice

506

494
The Gull
더 걸
Japan

495
SAS-Diving Suits
사스
Japan

496
Sherwood Scuba
셔우드 스쿠바
USA

497
Waterman
워터맨
Korea

498
Mcnett
맥넷
USA

499
Scubapro
스쿠바 프로
USA

500
Sea Quest
씨퀘스트
USA

501
Tusa
투사
Japan

502
Cetus
씨터스
Korea

503
Seac Sub
색서브
Italy

504
US Divers
유에스 다이버
USA

505
Aquaz
아쿠아즈

506
Underwater Kinetic
언더워터 키네틱
Korea

507
Amphibico
엠피비코-수중촬영 장비
Japan

508
Genesis
제네시스
USA

509
Aqua Lung
아쿠아 렁
USA

510
Uwatec
우바텍
Swiss

511
Sea Hornet
씨호넷
Australia

512
Cetacea
세타시
USA

513
Suunto
순토
Swiss

514
Dacor
다코어
USA

515
Spiro
스피로
France

516
Mares
마레스
Italy

517
The British Sub-Aqua Club
브리티쉬 서브-아쿠아 클럽
Great Britain

518
Apollo
아폴로
Japan

519
Nexus
넥서스-수중촬영 장비
Japan

507

508

509

510

512

511

513

514

517

515

516

518

519

520
Nippon Comsys Corporation(Japan)

521
Fujita
후지타
Japan

522
Taisei Corp
타이세이
Japan

523
Dongsin Housing
동신주택
Korea

524
Korea High Speed Rail Construction
Authority
한국고속철도건설공단
Korea

525
Kukdong Construction
극동건설
Korea

526
UDK Construction Inc.
유디케이 건설
Japan

527
Cofiroute-The Express Highway
Authority
프랑스 고속도로공단
France

528
ChungGoo Construction
청구 건설
Korea

529
Myong Ji Construction Co.,Ltd
명지건설
Korea

530
Multicon
멀티콘
USA

531
Hyanglin Village
CL:Daewoo Construction
향린빌리지
Korea

521

522

523

524

525

526

527

528

530

529

531

532

533

534

535

536

537

538

539

540

541

542

543

544

545
DongSung Construction
동성건설
Korea

546
SK Homex-A. P. T. Brand
에스케이 호맥스
Korea

547
Seoho Development
서호개발
Korea

548
Kyudenko Corporation-Electric
Power, Construction Company.
큐덴코 건설
Japan

549
Byek San Construction
벽산건설
Korea

550
Mors
모즈
Natherland

551
Dongyang Express Construction
동양고속건설
Korea

552
Kwun Young
(주)건영
Korea

553
Clean Valley
크린벨리
Korea

554
MSG
USA

545

546

서호개발주식회사

547

548

549

550

551

552

Clean Valley

553

554

555

556

557

558

559

560

559

561

562

563

564

565

555
Uchino
우치노
Japan

556
Satoh Kohtiu
사토 코티우
Japan

557
TeaYoung Construction
태영건설
Korea

558
Amstelland Concembeheer
Natherland

559
Kokensha
코켄샤
Japan

560
ECE:Land Development
CL:City Curture Symposium Manaco
Japan

561
Prime Construction & Engineering
프라임 산업·건설·엔지니어링
Korea

562
Korea Land Development Corp.
한국토지개발공사
Korea

563
Haseko Corporation-Construction &
Real Estate Development.
하세코
Japan

564
Gramercy Plaza
그러머시 플라자
USA

565
Mitomo Corporation
미토모 건설
Japan

566
Indian Construction Company
인디안 건설
USA

567
Matsuo Construction Co.,Ltd
마츠오 건설
Japan

568
Otake
오타케
Japan

569
Korea Construction Management
Corporation
한국 건설 관리공단
Korea

570
Alnet Home
아르넷 홈
Japan

571
Ministry of Construction &
Transportation
한국 건설교통부
Korea

572
Tatara Co.,Ltd-Engineering
타타라
Japan

573
Korea Highway Construction &
Service
고속도로시설공단
Korea

574
Hyundai Construction
현대건설
Korea

575
O' Dyssey-A. P. T. Brand
CL:ChungGoo Construction
오디세이-아파트 브랜드
Korea

576
Woobang Construction
우방건설
Korea

566

567

568

569

570

571

572

573

574

575

576

578

577

579

580

581

577
Grupo Coin
그루프 코인
Maxico

578
Nissan Construction
닛산건설
Japan

579
Seoho Construction
서호건설
Korea

580
HanYang Co.,Ltd
한양건설
Korea

581
Dongah Construction
동아건설
Korea

582
Daewoo Construction
대우건설
Korea

583
Taurus Construction
토러스 건설
USA

584
Mazerini Constructors
마제리니 건설
Brazil

585
New Seoul Int'l Airport Freeway Co.,
Ltd.
신공항고속도로주식회사
Korea

지구촌건설, 대우건설
582

583

584

585

586
Obayashi Corporation
오바야시 건설사
Japan

587
Hyundai A. P. T
현대 아파트
Korea

588
Shinbang Co.,Ltd
신방
Korea

589
Korea National Housing Corporation
대한주택공사
Korea

590
New Korea Airport Construction
Authority
신공항건설공단
Korea

591
Baums Co.,Ltd-Engineerring Firm
바움스
Japan

592
Sekisui House
세키스이 하우스
Japan

593
Samjung Construction
삼정건설
Korea

594
Hatai Construction
해태건설
Korea

595
Posec
포스코개발
Korea

596
Hardin
하딘
USA

597
Siporex Korea Co.,Ltd.-Building
Materials
시포렉스
Korea

598
Kitaumegumi Inc.-Sub Constructor
키타우메구미
Japan

586

587

588

589

590

591

592

593

594

595

596

597

598

600

599

601

602

603

604

605

606

607

608

609

610

599
Better Homes and Gardens
베터 홈스앤가든
USA

600
Mitsui Fudosan
미츠이 부동산
Japan

601
Home to Home Real Estate Net
홈투홈 부동산 네트
USA

602
Hanto Vision
한투비젼
Korea

603
Modern Realty
모던 리얼티
Japan

604
Century 21
센츄리 21
USA

605
Urbest Members
CL:Haseko Urbest
올베스트 멤버스
Japan

606
Urbanet
울바넷
Japan

607
Bruck AG
브룩 AG
England

608
Miyagi Estate Center
미야기 부동산 센터
Japan

609
Commerce Court
커머스 코트
Canada

610
Rehouse Div. Mitsui Real Estate Sales
미츠이 부동산판매
Japan

611

611
Los Angels Center
USA

612
Coldwell Banker Real Estate Group
USA

613
Development Services of America
USA

614
Eton Properties
Hong Kong

615
Red Carpet
USA

616
US Department of Housing and
Urban Development
USA

617
Waterford Center
CL:Jordan Properties
USA

618
C.I.A. & Fukuoka Daiei Real Estste Inc
Japan

619
Bay Adelaide
Canada

620
Greystone
USA

612

613

614

615

616

617

618

619

620

621

622

623

624

625

626

627

628

629

630

631

621
La Carucha
라 카루차
Argentina

622
Silver Real Estate
실버 부동산
USA

623
Brooks Resources/Canyon Lakes
/Real Estae Development
부룩스 자원
USA

624
Water's Edge
워터스 에지
USA

625
Lucky Elephant Rent house
럭키 엘러펀드 렌트 하우스
Japan

626
Red Hawk
레드 호크
USA

627
Kiyonari Shoji
키요나리 소지
USA

628
Black Dog Land Company
블랙 도그 랜드
USA

629
College Park
칼리지 팍
Canada

630
Buckhead Plaza
벅헤드 프라자
USA

631
Real Estate Developer
부동산 개발
Canada

633
Kyongju Prime Beef(Korea)

634
Tallgrass Beef
USA

635
Ralston Purina-Horse Feeding and
Grooming.
USA

636
Polo Ridge Farms
USA

637
Indian Creek Farm
USA

638
Zenhanren Pig Farm
Japan

639
Comanche Canyon Horse Company
USA

640
Brad J Kerbs-Horse Breeding
USA

641
Shibahara Rakuno Kumiai-Stock
Farm, Cuttle.
Japan

642
Koga Butcher's-Meat
Japan

643
Zenno-Promoting Beef Sales
Japan

644
Cho's Rost Meat Restaurant
Korea

645
The Weller Institute At The Red Hawk
Ranch-Horse Training
USA

646
Dairy Farmers Inc.
USA

647
Act Meat Corporation
Canberra

634

635

636

637

638

639

640

641

642

643

644

645

646

647

648

649

650

651

652

653

655

654

656

657

658

659

648
Piggly Wiggly
USA

649
Pig&Pigs
Korea

650
Danish Crown
Denmark

651
Hannaeng
한국냉장주식회사
Korea

652
Halim & Co.,LTD
Korea

653
Hanwoobang
CL:An Sung Livesttock Corp.
Korea

654
Zen Non Chicken Foods Corp.
Japan

655
Global Pig Farms, Inc
Japan

656
Incubaddora
Maxico

657
Koiwai Farm
Japan

658
National Livestock Coorperatives
Federation
축산업협동조합중앙회
Korea

659
Myung Sung Co.
Korea

660

A·COOP

661

662

664

660
Food Services of America-Institutional
Food Distributor.
아메리카 푸드서비스
USA

661
A Coop-Agricultural Cooperative
농업조합
Japan

662
Indian Wells
인디언 웰스
USA

663
Nongmaro
농마로-유기농산물유통
Korea

664
The Agricultural Council of Denmark
덴마크 농업조합
Denmark

665
ALPIA-Agricultural Cooperative
엘피아-농업조합
Japan

666
Agrimex-Agricultural products & trade
애그리 맥스
Bulgaria

667
Amerifresh-Fruits & Vegetables
아메리후레쉬
USA

668
Naturland
네이처랜드
Turkry

669
Toka Osaka Co.,Ltd
토카 오사카
Japan

670
Joongwon Farm Products
중원 농산물
Korea

663

665

666

667

Naturland

668

669

669

670

671

672

673

674

675

676

677

678

679

680

681

682

683

684

671
Mimuro
Japan

672
Mascot for Mimuro
Japan

673
Ecovin
Germany

674
E.Cecchi Farms

675
Kuri Fruit Corp.
Korea

676
Springfield Farmers Market

677
FRUT.ER ITALY:Tropical Fruits &
Vegetables
CL:Co.V.O.E.R.
Italy

678
Moonlight Mushrooms
USA

679
Australian Horticultural Corp.
Australia

680
Agricultural & Fishery Marketing
Corporation
Korea

681
Ito Farm-Vegetable Brand
Japan

682
Japan Agricultural Cooperatives
Japan

683
Aguricultural Cooperatives
Korea

684
Agricola Soledad-Agricultural
Chile

685
Ewa Beach Fish Market
이와 비치 피쉬 마켓
USA

686
Icicle Seafoods, Inc.
USA

687
O' Keefe' s Fisheries
Canada

688
Samho-Marine Products
삼호물산
Korea

689
Dae Nong
(주)대농
Korea

690
Happy House-Boiled Fish Paste
Brand
행복이가득한집
Korea

691
Philippine Marine Food
필리핀 수산식품
Hong Kong

692
Jumping Salmon-JH Frematad A/S
점핑 살몬
Norway

685

686

687

688

689

690

691

692

694

696

699

700

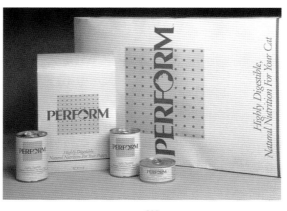

693

695

697

698

HOKUREN PET FOODS

701

693
Perform
퍼폼
USA

694
The IAMS Company
USA

695
Samyangsa
삼양사-식품,사료
Korea

696
Rokko Pet
록코펫
Japan

697
SDX-Dog Food Supplement
USA

698
Heinz Foods Inc.
헤인즈-강아지,식품판매
USA

699
Tail Waggers
테일 웨이지즈
USA

700
Gaines/Ajinomoto General Foods
게이네스 아지노모토 제네럴 푸드
Japan

701
Hokuren Pet Foods
호쿠렌 페트 푸드
Japan

702
Lorenzo Restaurant Italiano(Hong Kong)

North Shore
BISTRO

703

704

주식회사 놀부

705

estiatorio Milos

706

Japanese Restaurant

MIYAKO

709

STACKS'

707

708

CUISINE PROVENÇALE

JUNIPER

710

OYSTER HOUSE
ELLIOTT'S
SEAFOOD
RESTAURANT

711

聘珍樓
HEICHINROU

712

713-1
Today Restaurant
투데이·가족레스토랑
Korea

173-2
Mascot for Today Restaurant
투데이 마스코트
Korea

714
Rakuich Saikan
라쿠이치 사이칸
Japan

715
The Old Hall Hotel Restaurant
오드 홀 호텔 식당
Great Britain

716
Red Lobster
레드 랍스터
USA

717
Okamoto Co.,Ltd-Japanese
Restaurant
오카모토
Japan

718
Suppers Restaurant
서퍼즈 레스토런트
USA

719
Mangjia Pasta
망지아 파스타
Japan

720
Cafe Bellissimo
벨리씨모 카페
USA

713-1

713-2

714

715

716

717

718

719

720

721

723

Designer's Cafe Restaurant

724

TAEPYONGRO CLUB

726

Fast Dining Restaurant

728

729

THE MEZZANINE

722

725

727

730

731

721
Fontana
CL:Dai-Ichi Hotel Tokyo Bay
폰타나
USA

722
The Mezzanine-Apex Enterprise
메자닌
Korea

723
Positano Restaurant-Italian Restaurant
포시타노 식당
USA

724
Joy O'clock
CL:Daily Co.,Ltd.
조이 오클락-디자이너 까페, 식당
Korea

725
Tres Hermanas Restaurant
트레스 헤머나스 레스토런트
USA

726
Taepyoungro
태평로-신라호텔 중국식당
Korea

727
Dennys Restaurants
데니스 레스토랑
USA

728
Dash Rush
데시러시-베트남 외식업체
Korea

729
Wild Goose Cafe
와일드구즈 카페
USA

730
Restaurant le Chef Mechan
쉐프 메첸 식당
Japan

731
Her-Thai Restaurant
허-타이 레스토런트
Hong Kong

732
Vesta Dipping Grill
베스타 디핑 그릴
USA

733
Weird Grub Club
CL:The Food boys Restaurant
푸드 보이즈 레스토런트
USA

734
Tomorrow's Harvest-Charitable food
distributor
투마로우즈 하베스트-음식판매, 배달
USA

735
Hayashi Kokaen-Chinese Restaurant
하야시 코카엔
Japan

736
Gran.A
그랑.에이-노보텔 엠버서드호텔 식당
Korea

737
Yagura-Sushi Shimaya
:Sushi Restaurant
야구라 스시 시마야
Japan

738
Chi Chi's Inc
치치즈
USA

739
Nyx & Nox Pub Restaurant
서울 리즈칼튼호텔 닉스 앤 녹스
Korea

740
Le Bistro Shiseido
르 비스트로 시세이도
Japan

741
Benihana of Tokyo-Japanese
Restaurants
베니하나 도쿄
Japan

742
Oscar's Restaurant-Shirmere
Apartment Hotel
오스카즈 레스토랑
USA

733

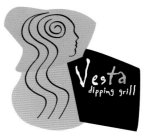

732

734

735

737

736

739

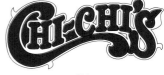

738

740

741

742

KFC(USA)

743
KFC
케이에프씨
USA

744
Taco Bell(Old)
타코벨(舊)
USA

745
Tony Maroni's Pizza
토니 마로니스피자
USA

746
Chaw Chaw
차우차우
Korea

747
Wendy's
웬디스
USA

748
Sung Shin Je Pizza Co., Ltd.
성신제피자
Korea

749
Pizza & Joy
피자엔조이
Korea

750
Kenny Rogers
케니로저스
USA

751
Papa gino's
파파지노
USA

743

744

745

747

746

748

749

750

751

752

753

754

755

756

757

752
Charlotte Square
샤롯 스퀘어
Hong Kong

753
Hardy's Food System Inc.
하디스 푸드 시스템
USA

754
Burger King
버거킹
USA

755
Bennigan's-Family Restaurants
CL:Pillsbury Company
베니건스
USA

756
McDonald's Corp.
맥도날드
USA

757
Dunkin' Donuts of America
던킨 도넛츠
USA

758
Jessica's Pizzeria
제시카 피자리아
Japan

759
Pizza Hut(Old)
핏자헛
USA

760
Wieners land-Hot dog Shop
위너스랜드
Korea

761
Domino's, Inc
도미노피자
USA

762
Mister Pizza
미스터피자
Korea

763
Redpin
레드핀
Korea

758

759

760

761

762

763

Foods / 食品 / 식품

766
Pulmuone
풀무원
Korea

767
Greenville
CL:Doosan Foods Co., Ltd.
그린빌
Korea

768
Kumhung
햇미가·식품 종합브랜드
Korea

769
Paldo Foods
팔도
Korea

770
KRAFT
크레프트
Swiss

771
Conserves La Torre
Maxico

772
Woongjin Co., Ltd.
웅진 식품
Korea

773
Ottogi Foods
오뚜기식품
Korea

774
KoRyo Jung Foods.
고려정식품·전통식품
Korea

775
Nucare
뉴케어·특수영양식
Korea

776
Filomena's-Italian Pasta
Manufacturers
필로메나스
USA

777
Libby's/Libby, Mcneil & Libby
리비즈
USA

778
Morinaga Co.,Ltd.
모리나가 식품
Japan

766

767

768

769

770

771

772

773

774

775

776

Libby's

777

778

779
Kellogg Company
캘로그
USA

780
Okonomiyaki House Mizuno
-Food & Drink Business
오코노미야키 하우스 미즈노
Japan

781
Jong Ga Jip
종가집
Korea

782
LG Matgreen
LG 맛그린
Korea

783
Safeway Inc.
세이프웨이
USA

784
Edison 300
에디슨 300
Korea

785
Quaker Oats Company
퀘이커 우츠
USA

786
Palm Preserves
팜 프리저브즈
Brazil

787
General Mills
제너럴 밀즈
USA

788
Oxo-Tomato Sauce
옥소-토마토소스
Korea

789
Andre Klein
안드레 크라인
Switzerland

779

780

781

782

783

784

785

786

787

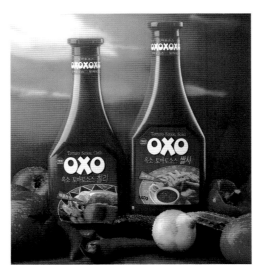

788

789

GENERAL
FOODS

791

DAESANG

792

790

793

794

"TCBY"

795

796

797

798

CHEIL JEDANG

제일제당

799

790
Crabtree & Evelyn London
크랩트리엔 에버린 런던
United Kingdom

791
General Foods Corporation
제너럴 푸드
USA

792
Daesang Group
대상그룹
Korea

793
Calpis Food Industry co., Inc
칼피스
Japan

794
Sannaedle
산내들(주)
Korea

795
TCBY System Inc.
USA

796
Cheil Jedang Food Division
제일제당 식품사업부
Korea

797
Cheil Jedang(Old)
제일제당(舊)
Korea

798
Haitai Group
해태
Korea

799
Cheil Jedang(New)
제일제당(新)
Korea

always Coca-Cola®

801
Nutra Sweet Company
뉴트라 스위트
USA

802
Nong Shim Co.,Ltd.
농심그룹
Korea

803
Benibana Food Co.,Ltd.
베니바나 식품
Japan

804
Penguin
주식회사 팽귄
Korea

805
Betty Cracker
USA

806
Lawry's Foods Inc
로우리즈 식품
USA

807
Miki Foods
미키 식품
Japan

808
Chung Jung Won
청정원
Korea

809
Arista
아리스타
USA

810
Cultor-Sugar Company
컬터
Finland

801

803

805

807

802

804

806

청정원

808

ARISTA

809

CULTOR

810

123

811

812

813

815

814

816

COHSEL HEALTHCARE FOOD

818

819

817

820

821

822

811
Delifresh Foods Corporation
델리후레쉬
Japan

812
RJR Nabisco, Inc
RJR 나비스코
USA

813
Our Home
아워 홈
Korea

814
Bing Grae Co.,Ltd(Old)
빙그레 식품(舊)
Korea

815
Mascot for Binggrae(New)
빙그레 식품 마스코트(新)
Korea

816
Binggrae
빙그레 식품
Korea

817
Tulbo Family
탈보네 식품
Korea

818
Cohsel Healthcare Food
코셀 헬스케어 푸드
Japan

819
Industria Brasileira De Alimenticios
Congelados
Brazill

820
Haechandle
CL:Samwon Foods Co., Ltd.
해찬들
Korea

821
Miwon(New)
미원(新)
Korea

822
Miwon(Old)
미원(舊)
Korea

823
Frich
CL:Binggrae Ice Cream
프리치
Korea

824
Pierrot
삐에로

825
Baskin Robbins 31
베스킨 로빈스 31
USA

823

824

825

826

827

828

829

830

831

832

833

834

835

ZOOSPORE

836

826
TCBY
USA

827
Thrifty
트라이프티 아이스크림

828
La Palette
라 파르떼
Japan

829
Friendly's
프랜드리
USA

830
Blue Bunny
블루버니

831
Aubrich
오브리치
Korea

832
Crape Paffe
크레이프 파페
Japan

833
Dolomiti
도로미티
Japan

834
Bresler's
브레슬러즈

835
OAK Classic
OKA 케이 클래식

836
Zoospore
주스포
Japan

837
Sweet Vanilla
스위트 바닐라
USA

838
Mr Chips
미스터 칩스
USA

839
Lotte Samkang
롯데삼강
Korea

840
Eigen Bitz
CL:Crown Bakery
아이겐 비체
Korea

841
Colomco
코롬코
USA

842
Yani
야니
Argentina

843
Dreyer's
드라이어스

844
Connoisseur
카너서

845
Haagen Dazs
하겐다즈
USA

846
Gelateria Gaggero
겔라테리어 가걸로
Genoa

837

839

838

EIGEN BITZE

Super Premium Ice Cream

840

841

843

842

844

Häagen-Dazs

845

846

Korea Tradition Tea(Korea)

847
Cafe de Colombia
콜롬비아 커피
Colombia

848
McKesson Water Products
맥커슨 워터
USA

849
Great Atlantic & Pacific Tea Company
그레이트 아틀란틱 앤 퍼시픽 티
USA

850
Lovis-New Life Water
로비스-뉴라이프 생수
Korea

851
Puriss Water
CL:Hite Brewery CO.,Ltd.
퓨리스
Korea

852
Greenwell Farms
그린웰 팜
USA

853
Rosebud Coffee
로즈버드
Korea

854
Key Coffee
키 커피
Japan

855
O'well Water
오웰
Korea

856
Twinings
트와닝
Great Britain

847

849

850

851

853

848

852

854

855

856

857

859

861

863

865

867

Santa fé

858

Lipton

860

maxell

862

MR.C☀FFEE

864

maxim

The wood porch faced east. First sunrise burned the mist from the hilly hollows, then dried out the webs spiders spun overnight between leaves of grass. A distant chainsaw cut into the birdsong; the rising wind whipped blue butterflies with stalks of goldenrod.

866

857
Dole
도올·쥬스.과일
USA

858
Santa f'e
산타페
Korea

859
Pepsi
펩시
USA

860
Lipton-Tea
립톤
USA

861
Del monte
델몬트
USA

862
Maxxell
멕스웰
Korea

863
Dongsuh Foods
동서식품
Korea

864
Mr. Coffee
미스터 커피
USA

865
Pocari Sweat
포카리스웨트
Japan

866
Maxim
맥심
Japan

867
Starbucks Coffee
스타벅스 커피
USA

868
Haitai Milk Food
해태유업
Korea

869
MD Food
엠디푸드
Danmark

870
Abbott Laboratories
애버트 레보러 토리즈
USA

871
Newzealand
뉴질랜드 치즈
Newzealand

872
Milco
CL:Haitai Milk
밀코
Korea

873
PPuyo-Children Yoghurt
뿌요·어린이유제품
Korea

874
Meito
CL:Kyoto Milk Industry Co.,Ltd
메이토
Japan

875
Maeil Milk Industry Co.,Ltd
매일유업
Korea

876
Heinz
하인즈
USA

877
Meiji Milk Products Co.,Ltd
메이지 밀크
Japan

878
Vilac Co.,Ltd
비락
Korea

879
Nakazawa Group-Dairy Products
Manufacture & Sales
나카자와 그룹
Japan

880
Planagro Pecuaria Industrial-Milk Bl
France

868

869

870

871

872

873

874

875

876

877

878

879

880

881
Remy Martin Rouis XIII

882
Saeanotsuru Co.,Ltd.
사에아노츠루
Japan

883
Banks
뱅커스
Great Britain

884
ChamNaMuTong Clean Soju
참나무통 맑은소주
Korea

885
Santa Barbara Wine Auction
산타바바라 와인 경매
USA

886
Windsor Premier
윈져 프리미어
Korea

887
Majuang
마주앙
Korea

888
Asahi
아사히맥주
Japan

889
Suntory
산토리
Japan

890
Carib
카리브
Great Britain

891
Jinro
진로
Korea

892
Kim Satgat
김삿갓
Korea

893
Barrel Scotch Whisky
CL:Whyte & Mackay
배럴 스카치 위스키
France

882

883

885

884

887

886

888

889

890

891

892

893

サッポロ生ビール

北海道

Just as the best malts, hops, and other ingredients are native to the northern climes, so does the Northern Star shine on this custom-brewed, limited-run edition bringing you the bracing taste of Hokkaido's rustic flavor.

894

Cafri

Premium Beer

895

Heineken

896

Miller

897

896

897

OB GATE

A GENUINE PLACE FOR GENUINE PEOPLE

898

RAZZLE · DAZZLE

AMERICAN BEER PUB

899

900

894
Sapporo Beer
삿포로맥주
Japan

895
Cafri Primium Beer
카프리프리미엄 맥주
Korea

896
Heineken
하이네켄
France

897
Miller
밀러
USA

898
Oriental Brewery Company 'OB Gate'
오비 게이트
Korea

899
Razzle Dazzle
CL:Oriental Brewery Company
라즐 다즐
Korea

900
Backhwa
백화주장
Korea

901
OB Seagram
오비 씨그램
Korea

902
The Hite
하이트맥주
Korea

903
Leinenliugel's
USA

904
Mein Brau
메인 브라우
Japan

905
Crown Beer
크라운맥주
Korea

906
Rathskeller Beer
라드스켈러 맥주
USA

907
Wagen Shuzo Co.
웨건 스조
Japan

908
Leuss
Germany

901

THE HITE.

902

903

904

905

906

907

908

135

909

910-1

KIRIN

910-2

Coors

912

911

ICE

913

NeX

914

915

916

909
Budweiser
버드와이즈
USA

910-1, 2
Kirin Brewery Co.,Ltd
기린맥주
Japan

911
Mauritius
마리티어스
Germany

912
Adolph Coors
아돌프 쿠어스
USA

913
Ice Beer
아이스맥주
Korea

914
Nex
넥스
Korea

915
Habereckl Brauerei
해버레클 브라우라이

916
Lite
CL:Miller Beer
라이트
USA

917
Takara Shozo Co.,Ltd
다카라 소주
Japan

918
Sapporo Breweries Ltd.
삿포로양조
Japan

919
Bärenquell
바렌퀼
Germany

920
Hite Beer
하이트맥주
Korea

921
Exfeel
엑스필
Korea

917

918

919

920

921

922-1

922-2

923

924

925

927

922-1, 2
Cass Beer
카스맥주
Korea

923
OB Beer
오비맥주
Korea

924
OB Sound
오비사운드
Korea

925
OB Lager
오비 라거맥주
Korea

926
OB Sky
오비 스카이맥주
Korea

927
OB Sky
오비 스카이이맥주
Korea

926

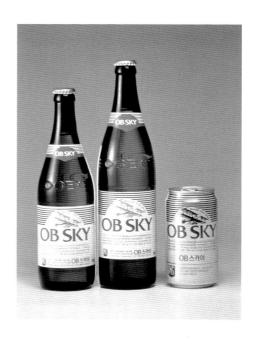

928
Hershey's Food Corp.
허쉬
USA

929
Lotte Confectionary(Old)
롯데제과(舊)
Korea

930
Ethel M Chocolates
에쎌 M 초콜렛츠
USA

931
Lotte Confectionary(New)
롯데제과(新)
Korea

932
Hugs
CL:Hershey Chocolate
헝즈
USA

933
Dongyang Confectionary
동양제과
Korea

934
Busy Bee Candy Line
비지비 캔디라인
USA

935
Haitai Confectionary
해태제과(舊)
Korea

936
American Candy Company
아메리칸 캔디회사
USA

937
Homemade
CL:Daily Co.,Ltd.
홈메이드
Korea

938
Ferrero
페래로
Switzerland

939
Cloud Nine, Inc
크라우드 라인

940
Denti Q
덴티·큐
Korea

928

930

932

934

936

938

929

931

933

935

937

940

MANDARIN ORIENTAL

942

941

943

944

945

946

947

948

949

941
Martina Zbornikova Prag-Bakery
마티나
Czechoslovakia

942
The Mandarin Shop-Cake Shop
만다린 숍
HongKong

943
The Brass Bell Bakery
브레스 벨 베이커리
USA

944
Alki Bakery and Cafe
앨키 베이커리
USA

945
Shiseido Parlour-Candy Shop
시세이도 파러
Japan

946
Great American Food -Bakery
그레이트 아메리칸 푸드
USA

947
Silra Bakery
신라명과
Korea

948
Mazetti
미제띠
Sweden

949
Earth Grains
어쓰 그레인즈
USA

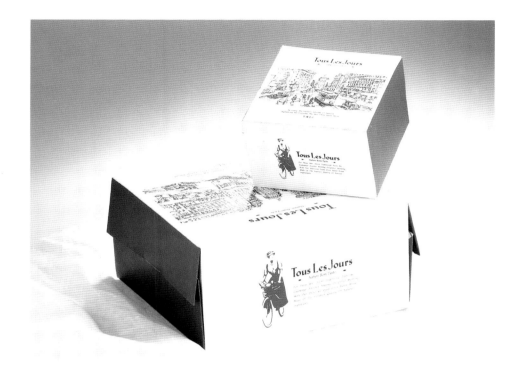

950

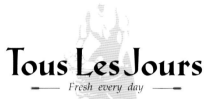

951

950
Broadmoor Bakery
브로드무어 베이커리
USA

951
Tous Les Jours
CL:CheilJedang
뚜레쥬르
Korea

952
Bakeries by the Bay
베이커리즈 바이 더 베이
USA

953
Pain De Vie
빵드비
Korea

954
SyaNi Co.,Ltd(Old).
샤니(舊)
Korea

955
In
인
Japan

952

953

954

955

956

957

959

958

960

961

962

963

964

956
Panem
파넴
Italy

957
Bon Matin
신라호텔 베이커리
Korea

958
Breadville
브래드빌
Korea

959
Paris Baguette(Old)
파리바게트(舊)
Korea

960
Paris Baguette(New)
파리바게트(新)
Korea

961
SyaNi Co.,Ltd.(New)
샤니(新)
Korea

962
COMO
꼬모
Japan

963
Bagels
베이글즈
Kuala Lumpur

964
New York Bakery
뉴욕제과
Korea

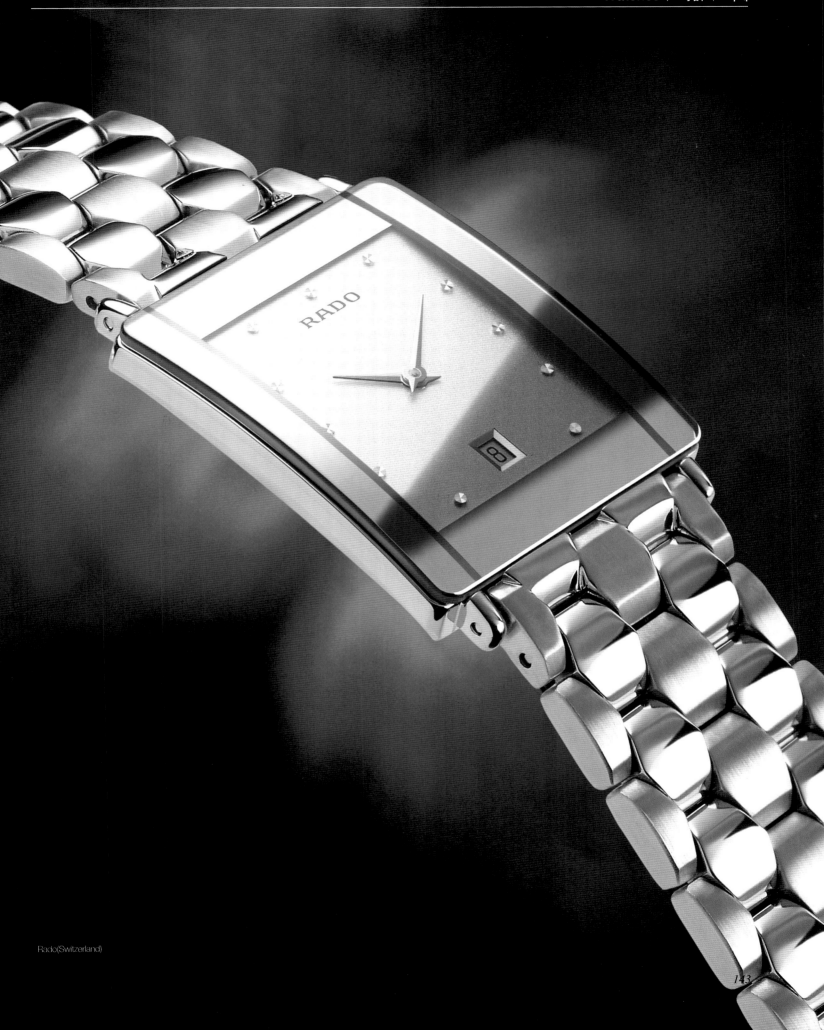

Rado(Switzerland)

966

965

967

968

969

970

GUCCI

971

972

973

974

975
Orient
오리엔트
Korea

976
Caritas
CL:Anam
카리타스
Korea

977
Movado
모바도
Swiss

978
Enicar
에니카
Swiss

979
Rado
라도
Switzerland

980
Citizen
시티즌
USA

981
Swiss Army
스위스 아미
Swiss

982
Seiko
세이코
Japan

983
Rolex
로렉스
Swiss

984
TAG Heuer
Swiss

975

976

977

978

980

979

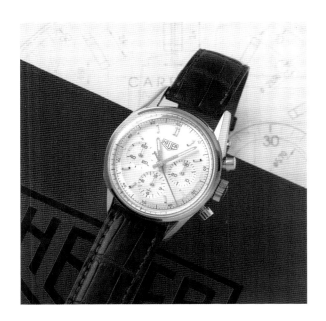

981

983

982

984

145

CHAGAL

986

985

OMEGA

987

988

990

989

PHILOS

991

Cygnus

992

993

994

EXITOGAR

995

996

985
Raffaello
CL:Rolens Co., Ltd.
라파엘로
Korea

986
Chagal
샤갈
Swiss

987
Omega
오메가
Swiss

988
ESQ
Swiss

989
Rollei
CL:Samsung Corporation
롤라이
Korea

990
Raymond Weil
레이몬드 웨일
Swiss

991
Philos
CL:Anam
필로스
Korea

992
Cygnus
시그너스
Korea

993
Certina
세르티나
Swiss

994
Baume & Mercier
Swiss

995
Exitogar
CL:Samsung
엑시토가
Korea

996
Bulova Watch or Clock
부로바
USA

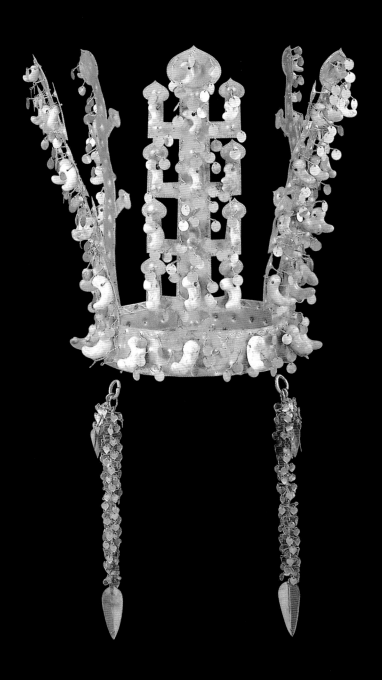

Crown-Silla 5th~6th C.(Korea)

148

998
Jewellery Vasara
주얼리 바사라
Japan

999
Jewelry Laila-Jewelry Shop
주얼리 라일라
Japan

1000
De Beers
드비어스
Canada

1001
G Valley-Jewelry Shop
지 벨리
Japan

1002
Eletto
에레또
Italy

1003
Hitomi Hama
히토미 하마
Japan

1004
Seoul Jewely Department
서울귀금속백화점
Korea

1005
Fino Allora
피노 알로라
France

998

999

G VALLEY

1001

De Beers

1000

1002

1003

1004

1005

1006

1007

1008

1009

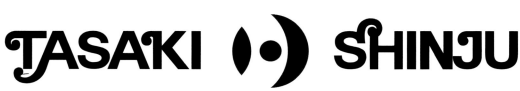

1010

1011

1012

1006
San Lorenzo-Works in silver
샌 로렌조
Italy

1007
Aya Azrielant

1008
Jose Hess
조세 헤세

1009
Oro America
오로 아메리카-금은세공
USA

1010
Tasaki Shinju
다사키 진주
Japan

1011
Le Supre Diamant Couture De Maki-
Jewelry Shop
CL:Miki Co.,Ltd.
Japan

1012
Goino
고이노
Japan

1013
Mini Gold
미니골드
USA

1014
Facere Jewelry Art-Jewelry Shop
USA

1015
Cartier-Jewelry, Fashion Company
까르띠에
France

1016
Lee Gold
리 골드
Korea

1017
My Jewel-Accessories Shop
마이 주얼
Japan

1018
Color Dressing-Jewelry Shop
칼라 드레싱
Japan

1019
Henry Jewelry Co.,Ltd -Jewelry Shop
헨리 주얼리
Japan

1020
Tiffany & Co.
티파니 앤 코
Swiss

1014

1013

1015

1016

1017

1018

1019

TIFFANY & CO.

1020

1021
Shellys(United Kingdom)

154

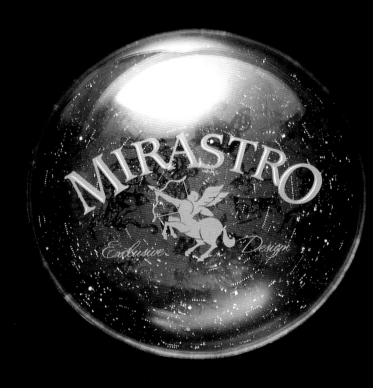

1022
Mirastro(Korea)

154

1023
Unique-Women's Shoes
유니크
Israel

1024
Hush Puppies
허시퍼피
USA

1025
Richard Lynn's Shoe Market
리차드 린즈 슈 마켓
USA

1026
Stride Rite Inc
스트라이트 라이트
USA

1027
Spris
스프리스
Korea

1028
AnnTaylor Studio
앤 테일러 스튜디오
USA

1029
Cat's Paw Rubber Company Inc.
캣츠 포 러버 컴퍼니
USA

1030
Capacci
가파치
Korea

1031
Ginza Diana
긴자 다이아나·구두
Japan

1032
Herkenrath
허켄라드
Germany

1033
Louis Vuitton
루이스비똥·가방, 피혁
Italy

1023

1024

1026

1025

1026

1027

1028

1029

1030

1031

1032

1033

1034

1035

1036

1037

SIMPLET

1038

ELCANTO

1039

1037
Clarks Originals
USA

1038
Simplet
심플리트
Korea

ASAHI

1040

1039
Elcanto
Korea

1040
Asahi
Japan

kangaroo

1041

1041
Kangaroo
캉가루-피혁
Korea

1042
Oodles
우들스-스포츠 종합패션
Korea

oo·dles'

1042

1043

1043
Moreschi
모르스치
Italy

1044

1045

1046

1047

1048

1049

1050

1051

1052

1054

KHOURY'S
"Clothing for the Entire Family"

1055

1056

1044
Loving Fashion Store
Japan

1045
Wannabe Fashion Store
Korea

1046
Orange County
Korea

1047
Editum Fashion Store
Korea

1048
Cclala Yoon Boutique
클라라 윤 부티끄
Korea

1049
La Piscina Boutique
라 피스씨나 부띠끄
Spain

1050
Milliore
밀리오레
Korea

1051
Western Exposure
USA

1052
Idol/Lyon
Japan

1053
Utoo Zone Fashion Store
Korea

1054
M.M. Reif & Co.,/Seawolf Enterprises
USA

1055
Khoury's Clothing Store
USA

1056
Mascot for Utoo Zone Fashion Store
유투존 마스코트
Korea

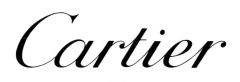

1058

1059

1060

1061

TSUMORI CHISATO

1062

Hiromichi Nakano

1063

besti belli

1064

1065

1066

1067

1068
Guess
게스
USA

1069
Clivia
크리비아
Korea

1070
Derbys
더비스
Korea

1071
Comodo
코모도
Korea

1072
Cotton Mark
코튼마크
USA

1073
Joinus
조이너스
Korea

1074
Pure New Wool Mark
울마크
USA

1075
O/X
오엑스·속옷
Korea

1076
Dongill Wool Textile Co., Ltd.
동일방직
Korea

1077
Avantoute
아방뚜뜨
Korea

1078
Teachang
태창
Korea

1068

1069

1070

1071

1071

1072

1073

1074

1075

1076

1077

1078

1079
Time(Korea)

1080
Mistake
미스테이크
Korea

1081
Bonne Sante
본느쌍떼
Korea

1082
Hanae Mori
하나에 모리
Japan

1083
Ebenezer
에벤에셀
Korea

1084
Besti Belli(Old)
베스티 벨리(舊)
Korea

1085
Fashion Institute of Kolon
코오롱 패션산업 연구원
Korea

1086
Body Studio
바디 스튜디오
Korea

1087
Levis Strauss & Company
리바이스
USA

1088
Ovis
오비스·가죽의류
Korea

1089
Charles Jurdan
찰스 쥬르당
France

1090
Wacoal
와코루
Japan

1080

1081

1082

1083

1084

1085

1086

1087

O V I S

1088

1089

1090

1091

1092

1093

1095

1094

1096

YVESSAINTLAURENT

1098

1099

1097

PLAYBOY

1100

1091
Brent Wood
브렌우드
Korea

1092
Nonno
논노
Japan

1093
Imperial
임페리얼
USA

1094
Jean Pier
쟌피엘
Korea

1095
Esquire
에스콰이어
Korea

1096
Pierre Cardin
피에르가르뎅
France

1097
Yvessaintlaurent
입생로랑
France

1098
Wordmark for Yvessaintlaurent
입생로랑 워드마크
France

1099
Countess Mara
카운테스마라
USA

1100
Playboy-Magazine and Enterprises
플레이보이
USA

1101
GAP
갭
Korea

1102
Si
씨
Korea

1103
Lofty Co.,Ltd-Bed Linen Wholesaler
로프티
Japan

1104
EnC
이엔씨
Korea

1105
Innanzi
인난찌
Korea

1106
Arthur Dixon
아써 딕슨
Korea

1107
Esprit
에스프리
Japan

1108
Benetton(Old)
베네통(舊)
Italy

1109
Benetton(New)
베네통(新)
Italy

1101

1102

1103

1104

1105

1106

1107

1108

1109

1110

1111

KOLON MODE

1112

1113

TRUGEN

1114

1115

1116

1117

VEN

ventura

1118

1119

1120

casual

1121

Bean Pole

1123
Burberrys
버버리
United Kingdom

1124
Noble House
노블 하우스
Germany

1123

1124

1125
G.V Incorporated
지 브이
Korea

1126
M. F. G. Co.,Ltd.
마르떼 프랑스와 저버
France

1127
Beati-Wedding Dress
베아띠-웨딩드레스
Korea

1128
LG Fashion CI
엘지패션
Korea

1129
System
시스템
Korea

1130
Ert'e Lingerie
Australia

1131
Brenntano
브렌따노
Korea

1132
Pirelli Sapsa
Italy

1133
Tomboy
톰보이
Korea

1134
Anna Perena
아나 페레나·여성의류
Korea

1135
YAH
아·청바지
Korea

1136
L'eggs
레그스
USA

1126

1125

1127

1128

1130

1129

1131

1132

1133

1134

1135

1136

1137
Autobahn
아우토반
Korea

1138
Frion
프라이언-에스에스패션
Korea

1139
Robert Schlapfer
로버트 스카랩퍼
Switzerland

Autobahn

1137

1138

1139

1140
Cha Cha S.C.L.
차 차 S.C.L.
Spain

1141
Jindo
진도그룹
Korea

1142
Chaville
샤빌
Korea

1143
Vivien
비비안
Korea

1144
Tomkid
톰키드
Korea

1145
Tictac
틱택
Japan

1146
Cheil Synthetic Textiles
제일합섬
Korea

1147
Manstar
맨스타
Korea

1148
BacKYang
백양
Korea

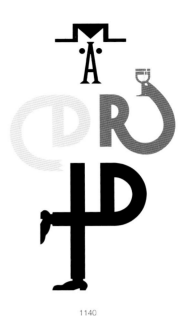

1140

1141

1142

1143

1144

1145

1146

1147

1148

Leg zone

1149

1150

SUNGDO

1151

1152

Abinna

1153

1154

SIENNE
aucun ne s'est ressemblé

1155

1156

1157

1158

1149
Legzone
레그존-패션, 잡화
Korea

1150
La Chemise Lacoste
라코스떼
France

1151
Sungdo Corporation
성도-종합패션
Korea

1152
Heang Ten
행텐
USA

1153
Abinna
아빈나
Korea

1154
Shin Won
신원그룹
Korea

1155
Sienne
CL:Kyungnam Wool Textile Co., Ltd.
씨엔느
Korea

1156
Paolo Gucci
파올로구찌
Italy

1157
Ssang Bang Wool
쌍방울
Korea

1158
Lefee
르페
Korea

1159
Polo Ralph Lauren(USA)

1160

1161

1162

1163
Fantom
팬텀·골프
Korea

1164
Audace
아우다체·골프
Italy

1165
Wolsey
울시·골프
Korea

1166
Rapido
라피도
Korea

1167
Laura Biagiotti
라우라 비오조티
Italy

1168
Pro Mate
프로 메이트·골프
Korea

1169
Jack Wolfskin
잭 울퍼스킨

1170
Black & White-Sportswear
블랙 앤 화이트
Japan

1171
Parelle Inc.
파렐러
USA

1172
Adabat
아다바트·골프웨어

1173
Line up Sportswear
라인업
USA

1163

1164

1165

1166

1167

1168

1170

1169

1171

1172

1173

ChristianDior

1174

1175

CLARINS
PARIS

1176

L'ORÉAL

1177

1178

1179

1180

1181

CHANEL

1182

1183

1184

1185

1186
Wella
웰라
Germany

1187
Sikmulnara
식물나라
Korea

1188
Sisley
시슬리
Italy

1189
Coreana
코리아나
Korea

1186

1187

1188

1189

1190

1191

1192

K O S É

1193

1194

EVAS

1195

1196

CHAMZONE

1197

1198

1199

1190
Isa Knox
이자녹스
Korea

1191
Clinique
클리니끄
USA

1192
Roc
록
France

1193
Kose
고세
Japan

1194
Kanebo
가네보
Japan

1195
Evas(New)
에바스(新)
Korea

1196
Nadri
나드리
Korea

1197
Cham Zone
참존
Korea

1198
Odette
오데뜨
Korea

1199
Namyang Aloe
남양알로에
Korea

1200
Estee Lauder
에스티 로더
USA

1201
Guerlain
겔랑
France

1202
Yvessaintlaurent
입생로랑
France

1203
Pola
폴라
Japan

1204
Yvessaintlaurent
입생로랑
France

1205
Oscar
오스카
Korea

1206
Dove
도브
USA

1207
Gio
지오
France

1208
Issilin
이씰린
Korea

ESTĒE LAUDER

1200

GUERLAIN
PARIS

1201

1202

POLA

1203

YvesSaintLaurent

1204

1205

1206

1207

ISSILIN

1208

1209

1210

1211

1212

DEBON

1213

g2.
gienic
지에닉
Skin Softener

1214

SHISEIDO

1215

BORYUNG
MEDIence

1216

Johnson&Johnson

1217

1218

1209
Ipsa
입사
Japan

1210
Kim Jung Mun Aloe
김정문 알로에
Korea

1211
Evas(Old)
에바스(舊)
Korea

1212
Etienne Algner
Germany

1213
Debon(Old)
드봉(舊)
Korea

1214
Gienic
지에닉
Korea

1215
Shiseido
시세이도
Japan

1216
Boryung Medience
보령 메디앙스
Korea

1217
Johnson & Johnson
존슨앤존슨
USA

1218
Sothys
France

1219
B Clap-Hair Salon
비 크랍
Japan

1220
Jieno-Hair & Esthetic Salon
지에노
Japan

1221
Willy Hair Wizzard
윌리 헤어 위저드
USA

1222
Han Byeol Diet
한별 다이어트
Korea

1223
Hair Studio
헤어스튜디오
USA

1224
Integree
앙떼그레
Italy

1225
Giscal Hair & Makeup
지스칼 헤어 메이크업
Italy

1226
TK Hair Shop
TK 헤어샵
Japan

1227
Gelinas
젤리나스
USA

1219

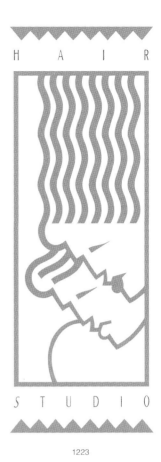

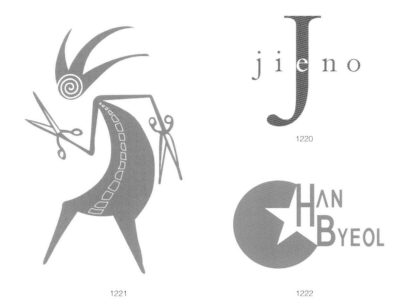

1221

1220

1222

1223

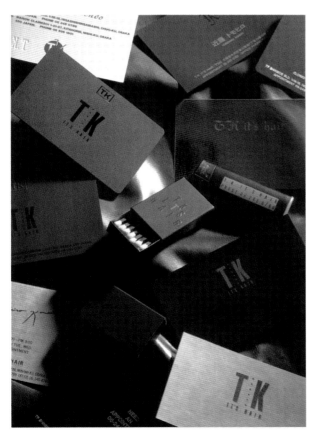

1224

1225

1226

1227

183

1228

1229

1230

1234

1236

BETH

1231

1232

1233

1235

1237

1238

1228
Richard Hayler Styling Salon
리차드 헤일러 스타일링 살롱
USA

1229
Jeff Maul Hair Stylist
제프 몰 헤어 스타일리스트
USA

1230
Mariko Nakagiri
마리코 나카지리
USA

1231
Beth
베쓰
USA

1232
Profiles-Hair Salon
프로파일
USA

1233
Liberty Hair Shop
리버티 헤어숍
USA

1234
Nubian Natural Hair Care System
누비언 네츄럴 헤어케어 시스템
USA

1235
Masterstyles of Dilworth
마스트스타일리스 오브 딜월쓰
USA

1236
Biyoshi
비요시
USA

1237
Hot Heads Hair Salon
핫 헤즈 헤어 살롱
USA

1238
De Castronovo-Hair Stylist
드 캐스트로노보
USA

1239
Taboo Hair Cutters
타부 헤어 커터
USA

1240
Moda Hair Design
모다 헤어 디자인
Canada

1241
Donna Tokumoto Hair Design
돈나 토쿠모도 헤어 디자인
Japan

1242
La Mop Hair Studio
라 몹 헤어 스튜디오
USA

1243
Queue-Hair Salon, Boutique
큐 헤어 살롱 부띠끄
USA

1244
Ripples Hair Salon
리플즈 헤어 살롱
USA

1245
Hair Peace Hair Salon
헤어 피스 헤어 살롱
USA

1246
Rebecca Cutter-Hair Stylist
레베카 커트
USA

1247
Zohra Spa & Body Clinique
조라 스파 앤 바디 크리니크
USA

1239

1240

1241

1242

1243

1244

1245

1246

1247

185

1248
Ltd Genetic Engineering Division(Korea)

1249
Hoechst
핵스트
Germany

1250
Yoohan Yangheang
유한양행
Korea

1251
Donghwa Pharmacy
동화약품
Korea

1252
Tukuhon
츠쿠혼
Japan

1253
Arax Pharmaceutical Company
아락스
Japan

1254
Handok Pharmacy
한독약품
Korea

1255
Sang A Pharmacy
상아제약
Korea

1256
Parke Davis And Company
USA

1257
PHD
CL:LG Chem. Pharmaceutical
Division
LG화학 'PHD'
Korea

1258
Kyowa Hakko Kogyo
쿄와 핫코 코교
Japan

1259
Materna
마터나
Korea

1260
Glaxo
그락소
USA

1261
Jungwae Pharma Corp.
중외제약
Korea

1249

1250

1251

1252

1253

1254

1255

1256

1257

1258

1259

1260

1261

1262

1263

1264

1265

1267

1266

1268

1269

1270

1271

1272

1273

1262
Jovy-Pharmacy Chain
조비
Japan

1263
Samsung Fine Chem.
Pharmaceutical Division BI
삼성정밀화학 'S.CROSS'
Korea

1264
Boots Pharmacy
부츠
Great Britain

1265
Lifix Inc.
리픽스
Japan

1266
Chugai
츄가이
Japan

1267
Boehringeringelheim Ltd.
베링거잉겔하임
Germany

1268
Chang Kun Dang
종근당
Korea

1269
Drogeri Neri
Switzerland

1270
Miles Laboratories Inc.
밀레스
USA

1271
Kwang Dong Pharmacy
광동제약
Korea

1272
Barnes
바네스
Great Britain

1273
Landa Pharmaceutical
랜더 파머수티컬
USA

1274
Hisamitsu
Japan

1275
Richard Douglas-Pharmacists
Great Britain

1276
Bayer
Germany

1277
Dae woong
대웅제약
Korea

1278
MECT Corp
Japan

1279
Ciba Geigy Pharmaceuticals/Ciba
Services
USA

1280
Mascot for Pangyi Zero
CL:Yukong Limited
유공 '팡이제로' 마스코트
Korea

1281
Pangyi Zero
CL:Yukong Limited
유공 '팡이제로'
Korea

1282
Chosun Pharmacy
Korea

1283
Dong A Pharmaceutical
동아제약
Korea

1284
Chicago Pharmacy
USA

1285
Searle
USA

1286
Pfizer
화이자
USA

1274

1275

1276

1277

1278

Maximizing Effort and Contribution to Therapeutics

1279

1280

1281

1282

1283

1284

1285

1286

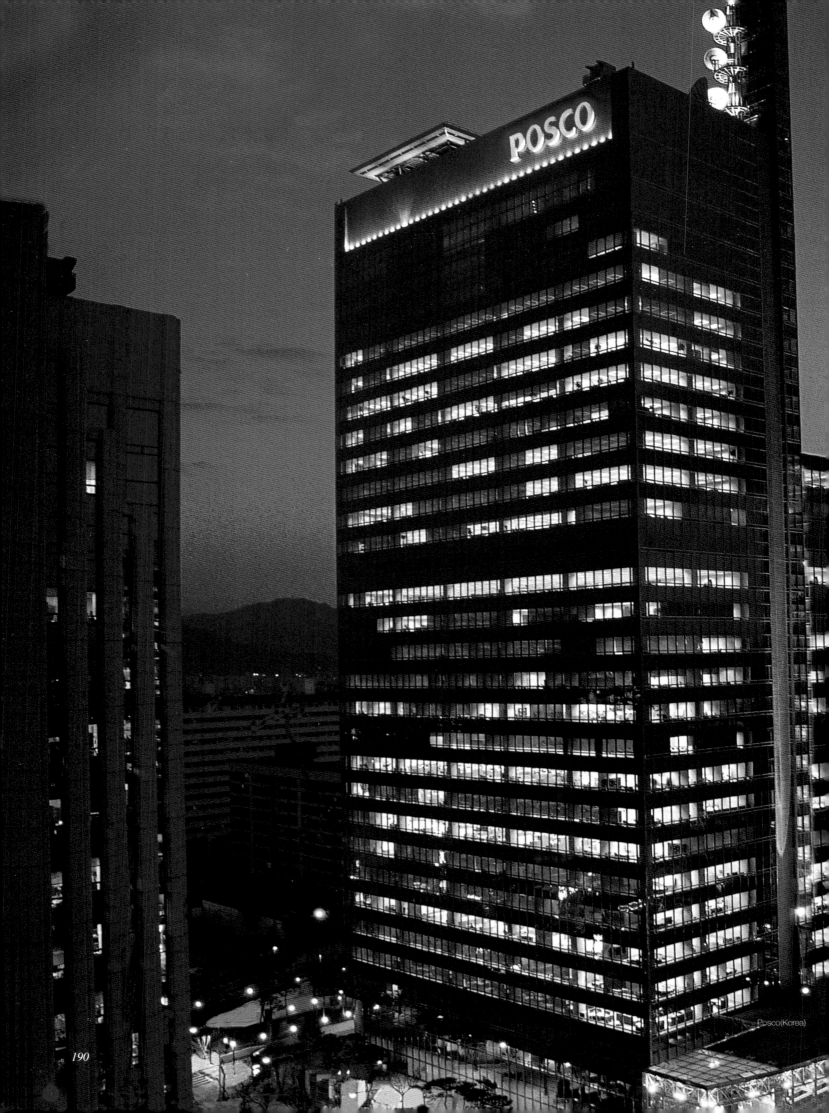

POSCO

Posco(Korea)

1287
Posco
포스코
Korea

1288
Po Hang Steel
포항제철
Korea

1289
Posmec
포철산기
Korea

1290
Posri
포스리·포스코 경영연구소
Korea

1291
Posrec
포스렉
Korea

1292
Mitsui Kinzoku
Non-Ferrous Metals Business
미츠이 킨조쿠
Japan

1293
United States Steel Corporation
유나이티드 스테이츠 스틸 코퍼레이션
USA

1294
Iscor Limited
South Africa

1295
Posco Steel Sales & Servics Co., Ltd.
포스틸
Korea

1296
Tokyo Steel
도쿄철강
Japan

1297
Unibros
유니브로스
Japan

1298
Makii Stainless
마이키 스테인레스

1299
SSU
Thailand

1300
Krupp

1287

1288

1289

1290

1291

1292

1293

1294

1295

1296

1297

1298

1299

1300

1302

1301

1303

1304

1305

1306

1307

1308

1309

1310

1311

1312

1301
US Steel Mining Company, Inc.
미국 철강산업
USA

1302
Tasaki Steel Co.,Ltd-Steel Wholesaer
타사키 철강
Japan

1303
Maruco Westmond
마루코 웨스트몬드
Singapore

1304
Chang Sung
창성그룹
Korea

1305
China Steel Chemical Corp.
중국 화학철강
China

1306
Sammi Group
삼미그룹
Korea

1307
BooKook Iron
부국철강
Korea

1308
Seah Steel Corp.
세아철강
Korea

1309
Thyssen
티이센
Japan

1310
NKK Corporation
Japan

1311
Kawasaki Steel Corp.
카와사키 철강
Japan

1312
Scon Centres Paris
스콘 센터레스 파리즈
France

1313
Simiz-Steel Wholesale Company
시미즈
Japan

1314
TIPS
팁스
USA

1315
Tsubaki of Canada Limited
Canada

1316
Metalia
메탈리아
Italy

1317
British Steel
영국 철강
United Kingdom

1318
Kawai Steel Co.,Ltd
카와이 철강
Japan

1319
Aluminum Company of America
아메리카 알루미늄
USA

1320
Rintatsu
린타추

1321
Chicago Heights Steel, Steel
Fabricating and Supply Firm.
USA

1322
Acesita
에이스사이타
Brazil

1323
Reynolds Aluminum Sales Co.
레이놀드 알루미늄 판매

1324
Washington Steel Corporation
워싱턴 스틸
USA

1325
Hitakenaka Steel
히타케나카 철강
Korea

1313

1314

1315

1316

1317

1318

1319

1320

1321

1322

1323

1324

1325

193

1326

1327

Techron

1328

1329

1330

1331

1332

1333

1334

1335

1336

1326
Korea Petroleum Development
Corporation
한국석유개발공사
Korea

1327
Conoco/Continental Oil Company
코노코
USA

1328
LG Techron
CL:LG Group
LG 테크론
Korea

1329
Marathon Oil Company
마라톤 오일
USA

1330
Arco/Atlantic Richfield Co
아커/아틀란틱 리치필드
USA

1331
SsangYong Group(Old)
쌍용그룹(舊)
Korea

1332
SsangYong Group(New)
쌍용그룹(新)
Korea

1333
Eg3
Argentina

1334
BASF
Germany

1335
Sun Company
썬
USA

1336
Ziebart
지바트
USA

1337

1338

1339

1340

1341

1342

1343

1344

1345

1346

1347

1348

1337
British Petroleum
브리티쉬 페트로엠
Great Britain

1338
Nippon Syokubai Co.,Ltd-Petro
Chemical
니폰 쇼쿠바이
Japan

1339
Oil Bank
CL:Hyundai Oil Refinery
오일뱅크
Korea

1340
Eni Group
에니 그룹
Italy

1341
Nippon Oil Company
니폰 오일
Japan

1342
Exxon Corp.
엑슨
USA

1343
Amoco Corp.
아모코
USA

1344
Seetec
씨텍
Korea

1345
Texaco Inc.
텍사코
USA

1346
Cepsa
셉사
Spain

1347
Castrol North America Inc.
캐스트롤
USA

1348
Enclean-Oil Brand
CL:SK Corporation
엔크린
Korea

1349
Sigma 6
시그마 6
Korea

1350
Tonen Chemical Corp
토넨 케미칼
Japan

1351
Wolf's head motor Oils-Oil Can Banks
울푸즈 헤드 모터 오일즈
USA

1352
Shell
쉘
USA

1353
Nichiban Chemical
니치반 케미칼
Japan

1354
Uniroyal
유니로얄
USA

1355
Q8 Oils
Q8 오일즈
Germany

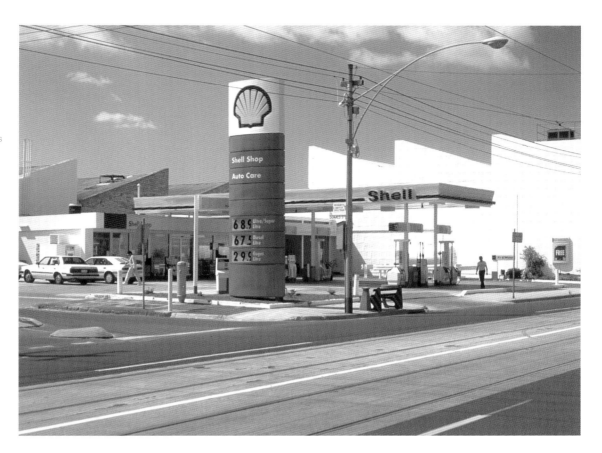

1349

1350

1351

1352

1353

1354

1355

1356

1357

1358

1359

1360

1361

1362

1363

SK Corporation

1364

UNOCAL 76

1365
Unocal 76
우노칼 76
USA

1366
Getty Oil
게티 오일
USA

1367
Cosmo
코스모
Japan

1368
Chemiway
CL:Maruzen Petrochemical Co.,Ltd.
케미웨이
Japan

1365

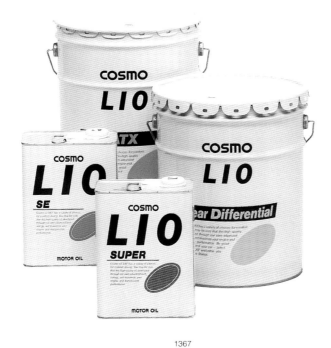

1367

1366

Chemiway

1368

1370

1369

1371

三井石化

1372

1373

1374

MITSUBISHI
KASEI

1375

Mobil

1376

1369
Shinetsu Chemical
시네츠 케미칼
Japan

1370
DEA Mineraloel AG
USA

1371
Caltex
CL:LG Group
칼텍스
Korea

1372
Mitsui Sekka
미츠이 세카
Japan

1373
LG Group
LG 그룹
Korea

1374
Hnahwa Group
한화그룹
Korea

1375
Mitsubishi Kasei Corp
미츠비시 카세이
Japan

1376
Mobil
모빌
USA

1377
Union Gas-Gas Company
유니온 가스
Canada

1378
Kawakos Gas
카와코스 가스
Japan

1379
Toho Gas
토호 가스
Japan

1380
Shibata Gas
시바타 가스
Japan

1381
Centra Gas
센트라 가스
Canada

1382
Petrol
페트롤
Peru

1383
Korea Gas Safety Corporation
한국 가스안전공사
Korea

1384
Petro Canada-Canada's Gas Station
페트로 캐나다
Canada

1385
Tasman Gas NL
타스만 가스
Australia

1386
American Gas Association(Old)
미국 가스협회(舊)
USA

1387
American Gas Association(New)
미국 가스협회(新)
USA

1377

1378

1380

1379

Centra Gas

1381

1382

1383

1384

1385

1386

1387

201

KyungDong

1388

1390

1392

1394

1396

TOKYO GAS CHEMICALS

1389

I-PRO

1391

POS ENERGY

1393

DanFlam

1395

1397

1398 1399

1388
KyungDong Energy
경동그룹
Korea

1389
Tokyo Gas Chemicals
도쿄 가스 화학
Japan

1390
Korea Gas Corp.(New)
한국가스공사(新)
Korea

1391
I-PRO Corp
아이 프로
Japan

1392
Korea Gas Corp.(Old)
한국가스공사(舊)
Korea

1393
Pos Energy
포스에너지
Korea

1394
Yookong Gas Limited(Old)
유공가스(舊)
Korea

1395
Danflam
덴플람
Denmark

1396
Tokyo Gas
도쿄가스
Japan

1397
Consumers Gas
컨수머즈 가스
USA

1398
Otaki Gas
오타키 가스
Japan

1399
Jung Woo Energy Co.,Ltd
정우에너지
Korea

1400
Energia
에너지아
Japan

1401
Dexon Co.,Ltd
덱슨전기·건전지제조
Korea

1402
Chubu Electric Power Co.,Inc.
츄부 전력
Japan

1403
Commax
코맥스
Korea

1404
Rayovac
라요백
USA

1405
Korea Electric Power Corp.
한국전력공사
Korea

1406
National Grid
내셔날그리드
Great Britain

1407
Kyuken Co.,Ltd
큐켄·전기설비
Japan

1408
Korea Power Engineering Co., Inc
한국전력기술
Korea

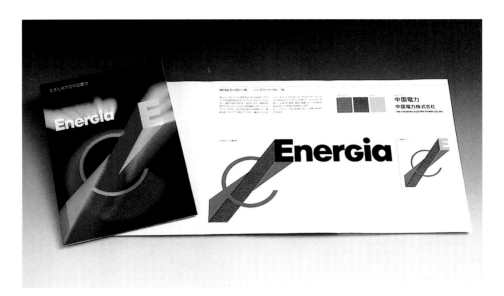

1400

1401

1402

1403

1404

1405

1406

1407

1408

1409
Duracel(USA)

1410
New York Power Authority
뉴욕 전력청
USA

1411
Shikoku Electric Power Co.,Inc
시코쿠 전력
Japan

1412
Energie Noord West
에너지 누드 웨스트
Netherland

1413
Namsung Electric Ltd.
남성전기산업
Korea

1414
Gould Inc.
건전지제조
USA

1415
Kyushu Electric Power Co.,Inc.
큐슈 전력
Japan

1416
Sunpower
선파워·건전지제조
Korea

1417
Daiko Electric CO., LTD.
다이코 전기
Japan

1418
London Electricity
런던전기
England

1419
Heesung Electricity
희성전선주식회사
Korea

1410

YONDEN

1411

NAMSUNG

1413

1414

SUNPOWER

1416

1418

1412

九州電力

1415

1417

1419

1420

1421

1422

1423

1424

1425

1420
Seuttong
(주)서통·화학,에너지
Korea

1421
China Electric Power Company
중국전기
China

1422
Yuasa Battery
요사 베터리
Japan

1423
Rocket Group
로케트그룹
Korea

1424
Dong A Elecom Co.,Ltd.
동아 일렉콤·전기부품제조
Korea

1425
Tokyo Electric Power Company
도쿄 전력
Japan

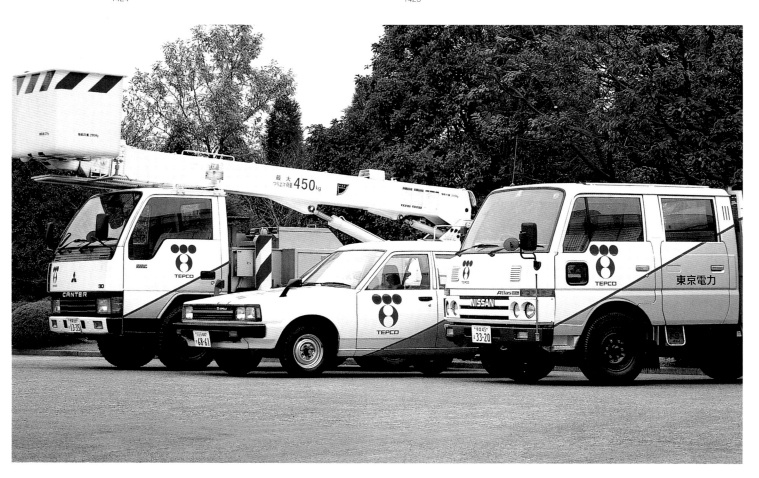

1426
The Inctec Inc
인크테크
Japan

1427
Samsung Fine Chem. Paint Division
삼성정밀화학 'SFC Paint'
Korea

1428
Hi-Q
하이큐-대한페인트 잉크브랜드
Korea

1429
Chokwang Paint Inc.
조광페인트
Korea

1430
Nippon Paint
일본페인트
Japan

1431
SamHwa Paint. Co., Ltd.
삼화페인트
Korea

1432
Dainippon Ink & Chemicals
대일본 잉크화학
Japan

1433
Fuller Paints
풀러 페인트
USA

1434
Martin Senour Paints
Spain

1435
Alesco Paints
알레스코
Japan

1436
Jaebeepyo Paints
제비표페인트
Korea

1426

1427

1428

1429

1430

삼화페인트

1431

1432

1433

1434

1435

1436

1437

1438

1439

1440

1441

1442

SKC

1443

1444

1445

1446

1447

1448

1437
Saehan Group(New)
새한(新)
Korea

1438
3M
쓰리엠
USA

1439
Hyundae Sheet
현대 쉬트
Korea

1440
Uni Maru
CL:Hankook Tmibers Co.
유니마루
Korea

1441
Toray
토레이
Japan

1442
Where Great Entertainment Design
그레이트 앤터테인먼트
USA

1443
SKC
Korea

1444
Tuscarora, Inc.
투스카로라
USA

1445
Marubeni Plax Corporation
-Plastics & New Materials Producer
마루베니 플렉스
Japan

1446
Korea Chemical
고려화학
Korea

1447
Du Pont
듀퐁
USA

1448
Korea Steel Chemical Co., Ltd.
한국제철화학
Korea

1449
MRC Polymers, Inc.
MRC 폴리머
USA

1450
Photo' go
포토고
USA

1451
Fuji Film
후지필름
Japan

1452
Konica film
코니카 필름
Korea

1453
Eastman Kodak Company
이스트맨 코닥
USA

1454
Agfa
아그파
USA

1455
LG Chemical
엘지화학
Korea

1456
Sunkyong
선경
Korea

1457
Saehan(Old)
새한(舊)
Korea

1449

1450

1451

1452

1453

1454

1455

1456

1457

1458

1459

1460

1461

1462

1463

1464

1465

1466

1467

1468

1469

1458
Procter & Gamble(New)
프록터 앤 갬블(新)
USA

1459
Procter & Gamble(Old)
프록터 앤 갬블(舊)
USA

1460
Colgate-Personal Care
콜게이트
USA

1461
Quantum-Chemical Manufacturer
퀀텀
USA

1462
Best Living
제일제당 '베스트리빙'
Korea

1463
OXY Corporation
옥시
Korea

1464
Clean Water Story
맑은물이야기
Korea

1465
Aekang Chemical
애경화학
Korea

1466
T.S. Group
TS 그룹
Korea

1467
Urquima- Chemicals/Raw Materials
우르키마
Spain

1468
Pigeon
피죤
Korea

1469
Showa Denko K.K.-General Seintific
Business
쇼와 덴코
Japan

1470
Codi
쌍용제지 코디
Korea

1471
Bosomi
보소미·기저귀
Korea

1472
Medident Total Toothpaste
메디덴트·치약브랜드
Korea

1473
Yuhan Kimberly
유한킴벌리
Korea

1474
Body Net
보디닛·목욕용품브랜드
Korea

1475
Oral-B
오랄-B
USA

1476
The Gillette
질레트
USA

1477
Kleenex
크리넥스
USA

1478
Magix
매직·여성용품
Korea

1479
ACCA Kappa
ACCA 케파·욕실용품 브랜드
italy

1480
Clean World
깨끗한나라
Korea

1481
Trisis-Total Treatment Shampoo
CL:Dong San C&G Co.
트리시스 샴푸
Korea

1470

1471

1472

1473

1474

1475

1476

1477

1478

1479

1480

1481

CoDI

Floral 300 White Facial Tissues

Pastel 300 White Facial Tissues CoDI

Codi(Korea)

1482
General Dynamics Corporation-
Defense Systems Manufacturer
제네럴 다이나믹스
USA

1483
Nara Instrument & Electric Inc.
나라계전
Korea

1484
Samsung Fine Chem.-
Non Invasive Glucose Monitor
삼성정밀화학 '터치트랙'
Korea

1485
Daelim Industrial Co., Ltd.
대림산업
Korea

1486
Doowon Climate Control Co., Ltd.
두원그룹
Korea

1484
Mirae Corporation
미래산업
Korea

1488
Kanglim
광림
Korea

1489
Segi Star
세기보청기
Korea

1490
Raytheon-Lexington, MA Defense
USA

1491
Medison
(주)메디슨
Korea

1492
Brother
브라더
Japan

1482

1483

1484

1485

1486

1487

1488

1489

1490

1491

1492

1493

1494

1496

1495

1497

1498

1499

1500

1501

1493
MerCruiser
머쿠루저
USA

1494
North American Rockwell-Industrial
Products/Flight Controls
노스 아메리칸 락웰
USA

1495
Lockheed(Old)
록키드(舊)
USA

1496
Fred To-Intlatable Aircraft
Manufacturer
프레드 투
Great Britain

1497
Starwave Corporation-Industry
스타웨이브
USA

1498
Grumman Aerospace Corporation-
Airplane Manufacturer
그루만 에어로스페이스
USA

1499
The Boeing Company
보잉
USA

1500
Duncan Aviation-Corporate Jet
Maintenance
던칸 에이비네이션
USA

1501
Cessna
세스나
USA

1502

1503

1504

1502
CAT-Industrial & Farm Equipment
USA

1503
Hanjung
한국중공업
Korea

1504
Cummings Engine-Engine
Manufacturer
USA

1505
Bosch
보쉬
Germany

1506
Iljin Group
일진그룹
Korea

1507
ZEXEL Corporation
젝셀
USA

1508
J.I. Case Co-Agricultural Equipment
Manufacturer
USA

1509
Black and Decker-Tools Manufacturer
블랙 앤 덱커
USA

1505

1506

1507

1508

1509

1510
Enduranali Corporation(USA)

1511
Banax
바낙스-낚시대 제조
Korea

1512
Harmony Corporation
하모니상사·앨범제조
Korea

1513
Xetex Corporation
제텍스
Korea

1514
Kolon Industries Inc.
코오롱
Korea

1515
Samsonite
샘소나이트
USA

1516
Taesung Wood Ind. Corp.
대성목재
Korea

1517
Keundo Corporation
주식회사 근도
Korea

1518
Eagon Industrial Co., Ltd
이건산업 주식회사
Korea

1519
NTEC Co.,Ltd.
주식회사 엔텍
Korea

1520
Jackal
자칼
Korea

1521
Dreizack Solingen
드레이쟉-칼제조
Germany

1522
Kitchen Aid
키친에이드
USA

1511

1512

1513

1514

1515

1516

1517

1518

1519

1521

1519

1520

1522

1523

1524

1525

1526

1527

1528

1530

1529

1531

1533

1534

1535

1523
Creart
Korea

1524
Star World Art
별나라미술공사
Korea

1525
Hallmark Cards, Inc.-Greeting Cards
USA

1526
Morning Glory
Korea

1527
Comatore
Korea

1528
Too Corp.
Japan

1529
Artbox
Korea

1530
Barunson Fancy Co.,Ltd
Korea

1531
Paeker
USA

1532
Sugar Factory
Korea

1533
Office Vender
Japan

1534
Acco World Corporation
-Office Products Manufacturer &
Supplier
USA

1535
Mascot for Uncle Alburt
알버트아저씨 캐릭터
Korea

1532

KCTV

1536
KCTV(Japan)

1537

1538

1539

1540

1541

1542

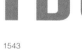

1543

1544

1545

1537
Fuji TV
Japan

1538
Tokyo Broadcasting System
Japan

1539
HBO
USA

1540
Star TV
Hong Kong

1541
American Broadcasting Company
USA

1542
Inchon Television Limited
인천방송
Korea

1543
Taegu Broadcasting Company
대구방송
Korea

1544
Pusan Broadcasting
Korea

1545
Mascot for Pusan Broadcasting
Korea

1546
Ulsan Broadcasting Corp.
울산방송
Korea

1547
ESPN
USA

1548
Nagasaki Culture Telecasting Corp.
나가사키 문화 방송국
Japan

1549
NHK
Japan

1550
Nippon TV Network
니폰 텔레비젼 네트웍
Japan

1551
China National Television
중화민국 공영 텔레비젼
China

1552
National Broadcasting Corparation
내셔널 방송국
USA

1553
Korea Broadcasting System
한국방송공사
Korea

1554
Columbia Broadcasting System
콜롬비아 방송국
USA

1555
National Banking Network
국립 은행 방송
USA

1556
VOSS-Television Company
Germany

1557
Jeonju Television
전주방송
Korea

1546

1548

1547

1549

1550

1551

1553

1552

1554

1555

1556

1557

TIME WARNER

1559

1558

1561

1560

1562

1563

1564

1565

1567

1568

1566

1569

1558
Munhwa Broadcasting Co., Ltd.
문화방송
Korea

1559
Time Warner
타임워너
USA

1560
Fox Inc.
폭스
USA

1561
Kwangju Broadcasting Co., Ltd.
광주방송
Korea

1562
Education Broadcasting System
교육방송
Korea

1563
Chungju Broadcasting Co., Ltd.
청주방송
Korea

1564
Life Time Television
라이프 타임 텔레비젼
Korea

1565
Seoul Broadcasting System
서울방송
Korea

1566
Korea Satellite Communications
한국위성방송
Korea

1567
CNN-Sports News from Cable News
Network
USA

1568
PBS-Public Broadcasting Service
USA

1569
Imagica-Satellite Communications
이메지카
Japan

1570
Hyundai Motor Broadcasting System
현대자동차 방송국
Korea

1571
Sports Television
스포츠 텔레비젼
Korea

1572
The Korea International Broadcasting
Foundation
아리랑 국제방송
Korea

1573
Daewoo Cinema Network
대우 시네마 네트워크
Korea

1574
Catchone Cable TV Network(Old)
캐치원(舊)
Korea

1575
Catchone Cable TV Network(New)
캐치원(新)
Korea

1576
Music Television
뮤직 텔레비젼
USA

1577
Barcelona Cable Television
바로셀로나 유선방송
Spain

1578
The CBS Late Movie/WMAR-
Television Program
CBS 심야영화/WMAR 텔레비젼 프로그램
USA

1579
Seocho Cable Television Network
서초 종합 유선방송
Korea

1580
KCTS
기독교 텔레비젼
Korea

1570

1571

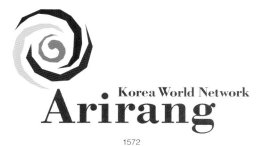

Korea World Network
1572

1573

1574

CATCH ONE
1575

1576

Barcelona Cable
1577

1578

Seocho Cable Television Network
1579

1580

1581

1582

1583

1584

m·net

1586

어린이TV

1585

Q Channel

1587

1588

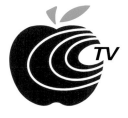

1589

SPORTS TV

1590

1581
Korea Music Television
한국 음악방송
Korea

1582
YTN-News
와이티엔 방송-뉴스
Korea

1583
The Nashville Network-Music
네시빌 방송-음악
USA

1584
My TV
마이 텔레비젼
Korea

1585
Child Television Network
어린이 텔레비젼
Korea

1586
M.net-Music
뮤직 네트웍-음악
Korea

1587
Cheil Communications Q Channel
제일기획 큐채널
Korea

1588
DongAh Television Network
동아방송
Korea

1589
CTN TV
Korea

1790
Korea Sport Television
한국 스포츠 텔레비젼
Korea

1591
The Disney Channel
디즈니 채널
USA

1592
Turner Network Television
튜너 네트웍 텔레비젼
USA

1593
BTN
Korea

1594
TV Network Nobeoka
노베오카 텔레비젼 방송
Japan

1595
Traffic Network
교통방송
Korea

1596
SIS News
서울국제위성뉴스
Korea

1597
G TV
Korea

1598
Hyundai Broadcasting System
현대 방송
Korea

1599
KAB
Japan

1600
Granada Hospital Services Ltd.-Hospital
TV Service
그라나다 병원방송국
Canada

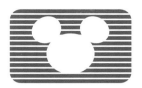 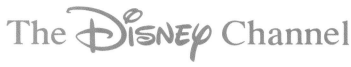

1591

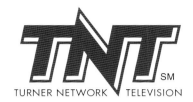

1592

1593

1594

1595

1596

1597

1598

1599

Granada Hospital Services Ltd.

1600

1601
Inter FM
인터 에프엠
Japan

1602
FM Fukui
에프엠 후쿠이
Japan

1601

1602

1603
PyungHwa Broadcasting
평화방송
Korea

1604
Pusan FM Bluewave
부산FM 블루웨이브 채널
Korea

1605
Tokyo FM
토쿄 라디오방송
Japan

1606
Maxximum
멕시멈
France

1607
WAKE
CL:FM Osaka
오사카 FM채널
Japan

1608
J Wave-Radio Station Campaign
제이 웨이브
Japan

1609
Radio Ranch
라디오 랜치
USA

1610
Air Radio FM88
에어 라디오 FM88
Japan

1611
Beat Jungle
비트 정글
Japan

1612
FM Wate
FM 와테
Japan

1604

1605

1607

1603

1606

1608

1610

1611

1609

1612

1613

1614

1615

1617

1619

1618

1620

CLASSIC fM

1621

1613
CBC/Radio Canada
Canada

1614
Dimension, CBS Radio Network-
Radio Program
디멘션
USA

1615
FM 802
Japan

1616
FMO
CL:FM Osaka Co.,Ltd
Japan

1617
WQCD CD 101.5 FM-Promotion and
Advertising
USA

1618
Buddhist Broadcasting System
불교방송
Korea

1619
Pro Radio-Television
프로 라디오
Switzerland

1620
Beat Station Fukuoka
비트 스테이션 후쿠오카
Japan

1621
Classic FM
클래식 FM
France

milim

1623

1625

1627

1629

1630

THEATER
für Vorarlberg

1622

1624

1626

1628

1631

1632

1622
Theater fur Vorarlberg
Austria

1623
American Conservatory Theater
아메리칸 컨서버토리 씨에터
USA

1624
Movies 7
무비스 세븐
USA

1625
Krastiu Sarafoff-Childrens Theatre
카라스티우 사라포뜨
Sofia

1626
Jungang Cinema
중앙시네마
Korea

1627
Myung Bo Plaza
명보플라자
Korea

1628
Pozoriste Dogadaj-Amateur
Humaristic Theater
Beograd

1629
CINEX
씨넥스
Korea

1630
Cine Plus
씨네플러스
Korea

1631
Cinama Avenue
씨네마 에비뉴
Japan

1632
Bosko Buha
Beograd

1633
The Old Globe Theatre
글로브 극장
USA

1634
National Actors Theatre
국립 액투어 극장
USA

1635
Suomalainen Nukketeattery-Puppet
Theater
Finland

1636
Theater Square, Orinda
씨에터 스퀘어, 오린다
USA

1637
The Old Globe Theatre
-Theatre Group
글로브 극장
USA

1638
National Theatre
영국 국립극장
Great Britain

1639
Stadt Theater Basel
스태트 씨에터 베설

1640
Glass Apple Theatre
글라스 애플극장
USA

1641
The Bathhouse Theatre
베쓰하우스 씨에터

1642
Shakespeare's Globe
세익스피어즈 글로브
Great Britain

NATIONAL
• ACTORS •
THEATRE

1634

1633

1635

1636

1637

1638

1639

1640

1641

1642

1643

1645

1644

1646

1647

1648

1649

1650

1651

1643
See & See
씨엔씨
Korea

1644
Volksbuurt Theater
볼크스부트 극장
Amsterdam

1645
Embassy Hotel Theatre
엠버시호텔 극장
USA

1646
Cinema Nova
노바 씨네마
Australia

1647
Havshakov
Bulgaria

1648
Zeebelt Theater
지벨트 극장
Natherland

1649
New National Theatre Tokyo
토쿄 시립극장
Japan

1650
Alliance Theater
극장연합
USA

1651
The Public Theater
공공극장
USA

GRAND LOUVRE

1652
Louvre Museum in paris(France)

1653

1654

1655

1656

1657

1659

1660

1658

1661

1662

1663

1664
Yonsei University Museum
연세대학교 박물관
Korea

1665
Contemporary Arts Museum
현대 예술박물관
USA

1666
Philadelphia Museum of Art
필라델피아 예술박물관
USA

1667
Seoul Design Museum
Korea

1668
Eureka! The Children's Museum-
Children's Museum
유레카 어린이 박물관
Great Britain

1669
Mca/Chicago Museum of
Contemporary Art
USA

1670
Toy Club-Tin Toy Museum in
Yokohama
USA

1671
The Bay Area Discovery Museum
USA

1672
Tagawa Museum of Art
타가와 박물관
Japan

1673
Poldi Pezzoli Museum
Swiss

1674
The New York Fire House
뉴욕 파이어하우스
USA

1664

1665

1666

1667

1668

1669

1670

1671

1672

1673

1674

ROYAL ARMOURIES MUSEUM

1675

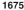

1676

토 지 박 물 관

1677

국립중앙박물관

1678

MUSEUM CONTEMPORARY TOKYO
OF ART
東京都現代美術館

1679

1680

1682

1681

1683

1684

1675
Royal Armouries Museum
영국 왕립 무기박물관
Great Britain

1676
Kanagawa Prefectural Museum of
Cultural History
카나가와시 문화역사 박물관
Japan

1677
Land Museum
CL:Korea Land Co.
한국토지공사 '토지박물관'
Korea

1678
National Museum of Korea
국립 중앙박물관
Korea

1679
Museum of Contemporary Art Tokyo
도쿄 현대 예술 박물관
Japan

1680
Volksbuurt Museum
볼크스부르트 박물관
Amsterdam

1681
EDO-Tokyo Museum
EDO 토쿄 박물관
Japan

1682
Museum Plakatu
프라카투 박물관
Japan

1683
AST Company-Museum/Resort
Development/Real Estate
AST 컴퍼니
Japan

1684
Sunritz Hattori Museum of Art
선리츠 하토리 예술 박물관
Japan

1685
Museum Facode
독일사냥 낚시박물관
Germeny

1686
Kakamigahala Aviation Museum
카카미가하라 항공우주 박물관
Germeny

1687
IMA-Indianapolis Museum of Art
IMA 인디아나 미술박물관
USA

1688
Hiroshima City Transportation
Museum
히로시마 교통박물관
Japan

1689
Children's Museum of Manhattan
맨하탄 어린이박물관
USA

1690
Bulgaria National Museum/Palace
불가리아 국립박물관
Bulgaria

1691
National Museum of Science
국립과학박물관
Canada

1692
Brunei Museum Silver jubilee
브루나이 박물관 25주년 축제
USA

1685

Indianapolis Museum of Art

1687

広島市交通科学館
HIROSHIMA CITY TRANSPORATION MUSEUM

1688

1689

1690

1691

1692

1693
The National Aviation Museum(Canada)

1694
Merrimack Valley Textile Museum
텍스타일 박물관
USA

1695
Euphrat Museum
유프라테 박물관
USA

1696
Himeji City Museum of Literature
히메지 박물관
Japan

1697
Museum Kultury Fizyczneji Turystyki
Poland

1698
Seattle Children's Museum
시애틀 어린이 박물관
USA

1699
Los Angeles Count Museum of Art
로스엔젤레스 카운트 예술박물관
USA

1700
Whitney Museum of American Art
아메리칸 예술박물관
USA

1701
Children's Museum of The Desert
어린이 박물관
USA

1702
Samsung Children's Museum
삼성어린이박물관
Korea

1703
Musee d'art Moderne et
Contemporain de Geneve
제네바 모던아트 박물관
Swiss

1704
Famine Museum- Museum about
Potato Famine
기아 박물관
Ireland

1694

1695

1696

1697

1698

1699

1700

1701

1702

1703

1704

1706

1705

1708

1707

1709

1710

1712

1713

1711

1714
Ba tsu Art Gallery
바츠 아트 갤러리
Japan

1715
Zone Living Design Center
존 리빙 디자인 센터
Japan

1716
Dyansen Japen
다이나센 제팬
Japan

1717
California Center for the Arts
캘리포니아 아트센터
USA

1718
National Museum of Contemporary
Art
국립현대미술관
Korea

1719
Ilmin Museum of Arts
일민미술관
Kore

1720
West Bend Gallery of Fine Arts
웨스트 벤드 아트 갤러리
USA

1721
Gallery Windsor
갤러리 윈져
USA

1722
Walnut Street Gallery
월너트 스트리트 갤러리
USA

1723
Gallery Its
갤러리 이츠
Japan

1724
Y. D. Park Gallery
박영덕화랑
Korea

1725
Ginja Arts Gallery
긴자 아트 갤러리
Japan

1714

1715

1717

1716

1719

1718

1720

1721

1722

1723

1724

1725

241

imagination

SUNKYONG

1726

EX**HIBITI**ON

H A L L

1727

1728
Human Space
휴먼스페이스·대우주택문화관
Korea

1729
Electrium
CL:Korea Electric Power Co.
한국전력공사 '일렉트리움'
Korea

1730
Mascot for '93 Expo Gold-Star
Technopia Pavilion
대전엑스포 럭키금성관 마스코트
Korea

1731
'93 Daejun Expo Exhibition Hall of IBM
'93 대전 Expo IBM관
Korea

1732
Arizona Science Center
아리조나 과학센터
USA

1733
The Pavilion of the Republic of Korea
베니스비엔날레 한국관
Korea

1734
Art Sonje Center
아트 선재 센터
Korea

1735
Housing Gallery
하우징 갤러리
Korea

1736
Alley-Event Hall
앨리 이벤트홀
USA

1737
Go-Yashiki-Wedding Hall
고야시키 웨딩홀
Japan

1738
Coex
코엑스·한국종합전시장
Korea

HUMAN SPACE

1728

전력홍보관

1729

1730

1731

1732

1733

Artsonje Center

1734

HOUSING GALLERY

1735

1736

GOYASHIKI

1737

1738

1739

1740

1741

1742

1743

1744

엑스포 '93

1745

1746

1747

1748

1749

1739
First Japan Exposition in Toyama '92
제1회 일본 토야마 박람회
Japan

1740
'90 Japanese Government Garden
Japan

1741
Mascot for International Travel Expo
'99 Kangwon-d0
강원도 국제관광박람회 마스코트
Korea

1742
International Travel Expo '99
Kangwon-d0
강원도 국제관광박람회
Korea

1743
Canada Expo '92
Canada

1744
'98 Kyungju World Culture Expo
경주세계문화엑스포
Korea

1745
Taejon Expo 1993
Korea

1746
World Design Exposition '89 Expo
Japan

1747
Mascot for '98 Kyungju World Culture
Expo
경주 세계문화엑스포 마스코트 '화랑이'
Korea

1748
Taejon Expo Mascot 1993
1993 대전 엑스포 마스코트 '꿈돌이'
Korea

1749
Pusan Fastival Expo
부산 축제박람회
Korea

1750
World Flower Exhibition Koyang '97
고양 '97세계 꽃 박람회
Korea

1751
Mascot for World Flower Exhibition
Koyang '97
고양 '97세계 꽃 박람회 마스코트
Korea

1752
Korea Food & Kitchen Expo '97
한국 식품.주방 박람회
Korea

1753
Commotion-Expo '86
커모우션
Canada

1754
'90 Tokyu Florium 109
CL:Tokyu Agency
토큐 꽃 박람회
Japan

1755
KID Expo
어린이 박람회
Korea

1756
1988 Saitama Exposition
사이타마 엑스포
Japan

1757
Japan Association for the International
Garden and Greenery Exposition
Japan

1758
Himeiji Municipality 100th Anniversary
히메이지 지방자치제 100주년
Japan

1759
Mascot for '99 Hanam International
Environment Exposition
하남 국제환경박람회 마스코트
Korea

1760
'99 Hanam International
Environment Exposition
하남 국제환경박람회
Korea

KOKO

1751

commMotion

1753

EXPO

1755

1756

'97 고양 세계 꽃 박람회

1750

FOODEX KOREA '97
KOREA FOOD & KITCHEN EXPO

1752

とうきゅう
フローリアム
109

1754

EXPO '90

1757

1758

1759

ENEXPO '99

1760

1761-1, 2
Harbor Fest, Inc.
하버 페스트
USA

1761-1

1761-2

1762
Cann Film Festival
칸느 영화제
USA

1763
21C Children's Film Festival
21세기 어린이영상캠프
Korea

1764
The 11th Blue Dragon Awards
제11회 청룡영화상
Korea

1765
Asian Association of UTAH-Film
Festival
유타 영화제의 아시아 연합 필름페스티발
USA

1766
Expo Marketing-Exporters
마케팅.정보 엑스포
India

1767
Arthur Andersen/Festival of Stravin
Sky Music
Great Britain

1768
Hitachi AV Campaign
히다치 오디오/비디오 켐페인
Japan

1769
PLC Fashion & Design Tour
PLC 패션, 디자인투어
Australia

1770
Live Collection-Culture Event
CL;Sagamihara Culture Citizen's
Foundation
라이브 콜렉션-문화이벤트
Japan

1771
Monterey Winemaker's Fastival
CL:Monterey Wine Country
Associates
몬트레이 와인축제

1762

1764

1766

1768

1763

1765

1767

1769

1770

1771

247

VENTURE

1773

1772

1775

1774

1776

DONG-A
INTERNATIONAL
MUSIC
COMPETITION

1777

1778

1779

**Industrie
Forum
Design
Hannover**

1780

1772
Samsung Literature Award
삼성 문예상
Korea

1773
Venture Business Fair '97
벤쳐 비지니스 박람회
Korea

1774
Hyogo Prefecture-Fastival for Health
and Welfare
효고 건강, 복지 페스티벌
Japan

1775
Japan Inter-Design Conference
국제 디자인대회
Japan

1776
Korea Theater Festival
한국영화 축제
Korea

1777
Dong A International Music
Competition
동아 국제음악콩크르
Korea

1778
Warld Paduk Championship
세계 바둑 선수권대회
Korea

1779
Loft Mono Mecca-Department Store
Event
CL;The Seibu Department Store
세이부백화점 행사
Japan

1780
Industrie Forum Design Hannover
유럽 디자인상
Germany

1781
Samsung Plaza
삼성프라자 태평로 사랑이야기
Korea

1782
Happy Halloween-Department Store
Champaign
CL:Seibu Department Store, Ltd.
세이부백화점 행사
Japan

1783
International Ad. Conference
호주 국제광고협회대회
Australia

1784
Chunhyang Festival
춘향제
Korea

1785
Conklin Shows
콘크린 축제
Canada

1786
Buena Vista College Festival
부에나 비스타 대학축제
USA

1787
Kwangju Biennale
광주 비엔날레
Korea

1788
Paris.IMS-Tenant Building Campaign
CL:Ims
파리스 아이엠에스
Japan

1789
International Butterfly Fair '95
'95 세계 나비박람회 캐릭터
Korea

1790
Boss's Day-Department Store
Campaign
CL:Seibu Department Store, Ltd.
보스데이·세이부 백화점행사
Japan

1782

태평로 사랑이야기
1781

IMAGINATION
1783

CHUNHYANG
FESTIVAL

1784

1785

1786

'95 KWANG JUBIENNALE

1787

1788

1789

BOSS'S DAY

1790

1791

'94
SEOUL
Living Design

1792

1793

1794

1795

1796

1797

DEPARTMENT

1798

1800

'95서울국제도서전시회
SEOUL
BOOKFAIR'95

1799

제1회 창의력 올림피아드

1802

1801

1791
Samsung Contributions to Society
사랑의 빛 나눔의 별·사회봉사 행사
Korea

1792
Seoul Living Design Fair
서울 리빙 디자인 페어
Korea

1793
The 18th Communication of May 18
Kwangju Uprising
제18회 5.18 광주 민중항쟁기념행사
Korea

1794
The World Deama Fastival
'97 세계연극제
Korea

1795
Seoul International Fashion Collection
서울 국제패션 컬렉션
Korea

1796
The 15th Inaugural of President
제15대 대통령 취임식행사
Korea

1797
The Korean Super Elite Moedl Contest
한국 수퍼엘리트 모델 선발대회
Korea

1798
X Department-Isetan Department Store
Event
CL:Isetan Co., Ltd
이세탄 백화점 행사
Japan

1799
Seoul Book Fair '95
'95 서울 서적 박람회
Korea

1800
Ims X'Mas-Tenant Building Event
CL:Ims
크리스마스 행사
Japan

1801
Telecom Show
통신정보 쇼
Korea

1802
Samsung Electronics Creativity
Olympiad
삼성전자 창의력 올림피아드
Korea

1803
Art Source
CL:Music Center of Los Angeles
County Education Div
아트 소스
USA

1804
IPI Seoul '95
'95 제44차 세계언론인총회
Korea

1805
Home Coming Day
CL:Samsung
Korea

1806
Sommet Halifax Summit
G7 정상회담 엠블럼

1807
UN Conference
코펜하겐 유엔사회개발 정상회의

1808
UN International Women's Yeal-
United Nations Program
'95 베이징 세계여성대회
USA

1809
Cyber Fastival '96
'96 사이버페스티발
Korea

1810
Macromedia Mediawave '97
'97 메디웨이브
Korea

1811
Asia Package Design Seoul
서울 아시아 패키지디자인 대회
Korea

1812
ICHPER.SD
건강, 스포츠, 댄스 학술대회

1804

1803

Home Coming Day

1805

1806

1807

'95.BEIJING

1808

1809

1810

Asia Package Design Seoul 1998

1811

1812

1813
Holland Dance Festival(Netherland)

1814
Dallas Ballet
달라스 발레단
USA

1815
Alvin Ailey-Dence Group
앨빈 에이레이
USA

1816
Ballet Tech
발레 테크
USA

1817
Ris & Danceries
리스 앤 댄서리스
France

1818
Universal Dance-Ballet School
유니버셜 댄스학교
USA

1819
Tosu Dance Studio
토스 댄스 스튜디오
Japan

1820
Give Peace a Dance
기브 피스 어 댄스
USA

1814

1815

1816

RIS & DANCERIES

1817

1818

1819

1820

1821

1822

1823

1824

1825

1826

1827

1828

1821
Osaka Philharmonic Orchestra
오사카 필하모니 오케스트라
Japan

1822
Children's Choir Sofia
소피아 어린이 합창단
Sofia

1823
Rock Band Ture
CL:SAMY Records
락밴드 투어
USA

1824
Triangle Opera
트라이앵글 오페라
USA

1825
What Next-Rock Band Logo
핫 넥스트
USA

1826
Streetliff-Jazz Band
스트리트립
USA

1827
Children's Radio Choir
어린이 라디오 합창단
Sofia

1828
Chicago Symphony Orchestra
시카고 심포니 오케스트라
USA

1829
Rogue Valley Symphony
로그 밸리 심포니
USA

1830
The San Damin Phoenix
샌 대민 피닉스
USA

1831
Rock Singer
CL:RTLJ Records
락싱어
Beograd

1832
Acadiana Symphony Orchestra
아카디아나 심포니 오케스트라
USA

1833
Esprit Orchestra
에스프리트 오케스트라
Canada

1834
Montreal Chamber Orchestra
몬트리올 챔버 오케스트라
Canada

1835
Northern State Texas University-
College Music Group
노던 스테이트 텍사스 유니버시티·대학
뮤직그룹
USA

1836
Boulder Philhamonic
볼더 필 하모니
USA

1837
Spontaneous Combustion
스판테이니어스 컴버스쳔
USA

1838
The Screamers-LA Punk Band
스크림스
USA

1829

1830

1831

1832

1833

1834

1835

1836

1837

1838

1839
MJJ Products-MichaelJackson
마이클잭슨 프로덕션
USA

1840
Bovine Militia-Rock Band
보빈 밀리셔
USA

1839

1840

1841
The Marriage of Figaro
피가로의 결혼
USA

1842
The Golden Voices of Opera
골든 보이스 오브 오페라
USA

1843
Fastival Symphony Orchestra
심포니 오케스트라 페스티발
USA

1844
Bridge To Life
브리지 투 라이프
USA

1845
San Jose Symphony
산 호세 심포니
USA

1846
Okayama Symphony Orchestra
오카야마 심포니 오케스트라
Japan

1847
Academie De Musique
뮤직아카데미
France

1848
Musica Club
뮤지카 클럽
Japan

1849
Lyric Opera
리릭 오페라
USA

1850
Tokorozawa PhilHarmony
토코로자와 필하모니
Japan

1851
No Tomorrow
노 투마로우
USA

1841

1843

1844

1845

1846

1847

1848

1849

1850

1851

257

1852

1852
Nova Trio
노바트리오
USA

1853
Anabel-Musician
아나벨
USA

1853

1854
Rock & Roll Hall of Fame+Museum
USA

1855
Buffalo State College Performing Arts
Center
버팔로 스테이트 대학 퍼포밍 아트센터
USA

1856
Dallas Opera-Opera Company
USA

1857
Suntory Hall
Japan

1858
National Opera Town Starazagora
스타자고라 국립 오페라타운
Sofia

1859
Yokohama City Nougakudo
요코하마시 가면극 극장
Japan

1860
Radio City Music Hall
USA

1861
Lincoin Center
USA

1862
Sejong Culture Hall
세종문화회관
Korea

1863
ENO/English National Opera-Opera
Company
Great Britain

1864
Seoul Arts Center
서울 예술의 전당
Korea

1865
Pacific Opera Company
USA

1855

1854

SUNTORY HALL

1857

1856

1858

1859

1860

1861

1862

1863

1864

1865

1866

1867

1868

1869

1870

1871

1872

1873

1874

1866
Hollywood Paramount Products
헐리우드 파라마운트
USA

1867
Michael Mann Production
미첼 만 프로덕션
USA

1868
Warner Bros Cinemas
워너브러스
USA

1869
Pelican Films Inc.
펠리칸 영화사
USA

1870
Magic Hour Pictures
매직 아우어 픽처스
Korea

1871
Cineplex Odeon
시네픽스 오데온
USA

1872
Milano Cinema
밀라노 씨네마
Italy

1873
Doradel Pictures
도라델 픽쳐스
USA

1874
Radio Vision International
라디오비젼 인터내셔널
USA

1875
Touchstone Production
터치스톤 프로덕션
CL:Walt Disney Productions
USA

1876
Magic Hour Pictures
매직 아우어 픽쳐스
USA

1877
Institute for Media Arts
미디어아트 연구소
USA

1878
Universal Pictures
유니버셜 영화사
USA

1879
Daven Film & Video
대번 필름 앤 비디오
USA

1880
Cultural Film Club
문화 필름 클럽
Iran

1881
Bulgarian Cinematography
불가리안 시네마토그래피
Sofia

1882
Hanmac Union
한맥유니온-영상프로덕션
Korea

1883
Tsunami Productions
츠나미 프로덕션
Japan

1884
TV House-Film & Video
텔레비젼 하우스
France

1875

1876

1877

1879

1878

1880

1881

1882

1883

1884

261

1885

1886

1887

1888

1889

1890

1891

1892

1893

1894

cinema de cinema

1895

1896

1885
Storybook Video
스토리북 비디오즈
USA

1886
Red Sky Films
레드스카이 영화사
USA

1887
Columbia Pictures
콜롬비아 영화사
USA

1888
Peccary King Productions
페카리 킹 프로덕션
USA

1889
CIC Video
Korea

1890
Arizona International Film
USA

1891
Playhouse Pictures
플레이하우스-만화영화사
USA

1892
Carmike Cinemas
USA

1893
Starmax
스타맥스
Korea

1894
United Artists
유나이티드 아티스츠
USA

1895
Cinema de Cinema
Japan

1896
The American Film Institute
아메리칸 필름연구소
USA

1897
Nexcom Co.,Ltd.
넥스컴
Korea

1898
CINETEX-Motion pictures
씨네텍스
USA

1899
Limelight
라임라이츠
USA

1900
Tulip Films
튤립 필림
USA

1901
Turner Classic Movies
튜너 클래식 무비즈
USA

1902
UFA
USA

1903
AIVF-Film Association
CL:Association of Inobponoent
Video and Film Makers
비디오협회
USA

1904
Errecerre
Spain

1897

1899

1903

1898

1900

1901

UFA

1902

1904

1905

1906

1908

1907

1909

1910

1911

1912

1913

1914

1915

1916

1905
Easy Writers Music Inc.
이지 라이트 뮤직
USA

1906
Hi Brite. Inc-Record Company
하이 브라이트
Japan

1907
Mickey Newberry-Singer, Songwriter
Composer
미키 뉴베리-작곡회사
USA

1908
Peacock Music Studio
피코크 뮤직스튜디오
USA

1909
Polygram Special Productions
폴리그램 스페셜 프로덕션
USA

1910
Consipio Records
콘시피오 레코드
Japan

1911
Bambina Kingdom Co., LTD
밤비나 킹덤-음악가 관리회사
Japan

1912
TNT Music Group
TNT 뮤직그룹
Hong Kong

1913
Crossroads Records
크로스로드 레코드
USA

1914
Wildcat Records/Windcheetah
Record Label
와일드켓 레코드
USA

1915
Capitol Records-EMI Of
Canada/GlassTiger
캐피탈 레코드
Canada

1916
Victory-Talent Production
빅토리
Japan

1917
Airborne Records-Record Company
에어본 레코드
Japan

1918
Virgin Records America, Inc
버진 레코드 아메리카
USA

1919
Squatt-Record Company
CL:CBS Records France
France

1920
Dreamworks
드림웍스
USA

1921
CBS Songs-Sheet Music Company
CBS 송즈
USA

1922
Guerrilla Records
게릴라 레코드
Japan

1923
Elektra Entertainment
CL:Warner Communications
엘렉트러 엔터테인먼트
USA

1917

1919

1918

1920

1921

**GUERRILLA
RECORDS**

1922

1923

1924

1925

1926

1927

1928

1929

1930

1931

1932

1933

1934

1935

1936

1924
Doremi Records
도레미 레코드사
Korea

1925
Canion Record
Japan

1926
ISM-Recording Studio
Japan

1927
Sound Sky Studio Inc-Recording
Studio
Japan

1928
Rising Inc.-Music Planning
Japan

1929
Cream
크림
USA

1930
Rock Records Inc
Hong Kong

1931
NEC Avenue Ltd-Audio Visual
Production

1932
Sky Station Inc.-Music Planning
스카이 스테이션
Japan

1933
Barclay Records
CL:Phonogrmme France
France

1934
Warner Music
워너뮤직
USA

1935
Samsung Nices
삼성 나이시즈
Korea

1936
WRAP
CL:Kukan Entertainment
Japan

1937
People's Bank-Supermarket Bank(USA)

1938

1938
Ing Bank, Post Bank
아이앤지 뱅크, 포스트 뱅크
Netherland

1939
kangwon Bank
강원은행
Korea

1940
Mascot for kangwon Bank
강원은행 마스코트
Korea

1939

1940

1941
The Citizen National Bank(Old)
국민은행(舊)
Korea

1942
Mascot for The Citizen National
Bank(Old)
국민은행 마스코트(舊)
Korea

1943
Merrill Lynch & Co., Inc
금융중개인협회
USA

1944
Cirrus System
시러스시스템·금융자동화시스템
USA

1941

1942

1943

1944

1945
Bank Line
뱅크라인
Korea

1946
Korea Exchange Bank
한국외환은행
Korea

1947
Korea Development Bank
한국산업은행
Korea

1948
Bank of China
차이나뱅크
Hong Kong

1949
TRW, Inc
USA

1950
VDK, Bank
Belgium

1951
Cost Saving
코스트 세이빙
USA

1952
Bank of Ayudhya
Thailand

1953
Kookmin Bank(New)
국민은행(新)
Korea

1954
Mascot for Kookmin Bank(New)
국민은행 마스코트(新)
Korea

1955
Citi Bank
시티은행
USA

1956
Glendale Federal Bank
그랜덜 퍼드럴 뱅크
USA

1945

1947

1949

1946

1948

1950

1951

1952

1953

1954

1955

1956

1957

1958

1960

1959

1962

1961

1963

1965

1964

1966

1967

1957
Unibank A/S
유니뱅크
Denmark

1958
Standard Bank of South Africa
남아프리카 스텐다드 뱅크
South Africa

1959
Raiffeisen Zentralbank Osterreich - Rzb
Austria

1960
Banesto-Banco Espanol De Credito
Spain

1961
The Yasuda Trust & Banking
야스다 신용은행
Japan

1962
Banco De Galicia
Argentina

1963
Mellon Bank
멜론 뱅크
USA

1964
Signal Bank
시그날 뱅크
USA

1965
Credit Communal-Gemeentecrediet
크레디트 커뮤널
Belgium

1966
Credit Local De France
크레디트 로컬 드 프랑스
France

1967
Turkish Emlak Bankasi
Turkey

1968
Banco De Sabadell
Spain

1969
Privatbanken
Denmark

1970
Janus Mutual Funds
야누스 뮤추얼 펀즈
USA

1971
Finansbank
파이낸스 뱅크
Turkey

1972
Service Bank Co.,Ltd.
서비스 은행
Korea

1973
The Royal Bank of Scotland
로얄 뱅크오브 스코틀랜드
Great Britain

1974
Multibanco Comermex
Mexico

1975
Kwangju Bank
광주은행
Korea

1976
An Hyp SpaarBank
Belgium

1977
Caja De Madrid
카자 데 마드리드
Spain

1978
Credit Foncier De France
France

1979
Credit Commercial De France
크레디트 커머셜 프랑스
France

1968

1969

1970

1971

1972

1973

1974

1975

1976

1977

1978

1979

1980

1981

1982

1983

BOK

1984

1985

1986

1987

1980
Sumitomo Bank
스미토모 뱅크
Japan

1981
Sun America
썬 아메리카
USA

1982
Tomato Bank
토마토 뱅크
Japan

1983
Koriyama Shinkin Bank
코리아마 신킨 뱅크
Japan

1984
The Bank of Korea(Old)
한국은행(舊)
Korea

1985
The Bank of Korea(New)
한국은행(新)
Korea

1986
Shinhan Bank
신한은행
Korea

1987
Mascot for Shinhan Bank
신한은행 마스코트
Korea

1988
Core States
코어 스테이츠
USA

1989
Peace Bank
평화은행
Korea

1990
The Oita Bank
오이타 뱅크
Japan

1991
Hana Bank
하나은행
Korea

1992
Bank of America
아메리카 뱅크
USA

1993
Seoul Bank
서울은행
Korea

1994
Community Savings
커뮤니티 세이빙즈
USA

1988

1989

1990

1991

1992

1993

1994

1996
BRF-Mortgage Credit Inctit. For Build.
Trade
Denmark

1997
Banco Portugues Do Atlantico
Portugal

1998
Dresdner Bank
드레스드너 뱅크
Germany

1999
Banca Del Monte Di parma
Italy

2000
Nzi Bank
New Zealand

2001
Kansallis-Osake-pankki
Finland

2002
Phildrew Ventures
필드류 벤쳐즈
United Kingdom

2003
TRI Bank
TRI 뱅크
Japan

2004
United Saudi Commercial Bank
유나이티드 사우디 커머셜 뱅크
Saudi Arabia

1996

1999

2002

2003

1997

1998

2000

2001

2004

2005

2007

2009

2011

2013

2014

2006

2008

2010

2012

2015

2016

2005
Jeonbuk Bank
전북은행
Korea

2006
Hiroshima Bank
히로시마은행
Japan

2007
Toho Bank
토호뱅크
Japan

2008
Banque De Groof
뱅크 드 그루프
Belgium

2009
Chohung Bank(Old)
조흥은행(舊)
Korea

2010
Taegu Bank
대구은행
Korea

2011
The Dutch National Bank
더치 내셔널 뱅크
Netherland

2012
Chase Manhattan Bank
체이스 맨하탄 뱅크
USA

2013
Boram Bank
보람은행
Korea

2014
Commercial Bank
상업은행
Korea

2015
Our Commercial Bank
아우어 커머셜 뱅크
Japan

2016
Pusan Bank
부산은행
Korea

2017
Harris Trust & Savings Bank
해리스 트러스트 앤 세이빙즈 뱅크
USA

2018
Oklahoma City's Liberty National Bank
오클라호마 시티즈 리버티 네셔날 뱅크
USA

2019
Caixa De Catalunya
Spain

2020
Newport Balboa Savings & Loan
뉴포트 볼보아 세이빙스 앤 론
USA

2021
Banco Italia
반코 이탈리아
Italy

2022
National Central Bank
네셔날 센트럴 뱅크
USA

2023
Cork and Limerick Savings Bank
코크 앤 리머릭 세이빙즈 뱅크
Ireland

2024
Plan De Prevoyance Populaire Cie
Bancaire
France

2025
Banco De La Provincia
Argentina

2026
The Hyogo Bank Ltd.
효고은행
Japan

2027
Luso International Banking
루소 인터네셔날 뱅킹
Macao

2018

2017

2020

2019

2022

2021

2023

2024

2025

THE HYOGO BANK LTD.

2026

2027

CAJA DE PENSIONES

2028
Caja De Pensions (Spain)

2029
ABN AMRO Bank
에이비엔 아모로 뱅크
Germany

2030
Dong Hwa Bank
동화은행
Korea

2031
Mitsui Taiyo Kobe Bank
미츠이 타이요 뱅크
Japan

2032
H&CB
한국주택은행
Korea

2033
Long Term Credit Bank
장기신용은행
Korea

2034
Kochi Bank
고치 뱅크
Japan

2035
Kyoung Nam Bank
경남은행
Korea

2036
Hanil Bank
한일은행
Korea

2037
Chohung Bank(New)
조흥은행(新)
Korea

2038
Heritage Bank
헤리티지 뱅크
USA

2039
KorAm Bank
한미은행
Korea

2040
First Bank
제일은행
Korea

2029

2031

2033

2030

2032

2034

2035

2036

2037

2038

2039

2040

2041

2042

2043

2044

2045

2046

2047

2048

2041
The Saitama Bank
사이타마 은행
Japan

2042
Swiss Volks Bank
스위스 볼크스 뱅크
Switzerland

2043
Public Sector Bank
퍼블릭 섹터 뱅크
India

2044
Deutsche Bank
도이치 뱅크
Germany

2045
Banco De Italia Y Rio De La Plata
Argentina

2046
Okobank
오코 뱅크
Finland

2047
InterBank/Uluslararasi
인터 뱅크
Turkey

2048
Banca Confia
밴커 콘피어
Mexico

2049
Surbank Setagaya
세타가야
Japan

2050
Whiteaway Laidlaw Bank
와이트어웨이 레이드로우 뱅크
United Kingdom

2051
First Wisconsin Bank
퍼스트 위스콘신 은행
USA

2049

WHITEAWAY
LAIDLAW
BANK

2050

2051

2052
Credit Agricole
크레디트 에그리콜
France

2053
Credit Europeen
크래디트 유로핀
Luxembourg

2054
Spaarkrediet
Belgium

2055
Banca Anonima Di Credito
Italy

2056
Credito Industriale Sardo
Italy

2057
First Interstate Bank Corporation
퍼스트 인터스터이트 뱅크 코퍼레이션
USA

2058
3 i Group(Old)
쓰리 아이 뱅크(舊)
Great Britain

2059
Instituto Bancario San Paolo
Italy

2060
Credit National
크래디트 내셔널
France

2061
Union Bank of Switzerland
유니온 뱅크
Switzerland

2062
Die Erste Osterreichische Spar-
Casse-Bank
Austria

2052

2053

2054

2055

2057

2056

2058

2059

2060

2061

2062

2063

2064

2065

2066

2067

2068

2069

2071

2070

2072

2073

2074

2063
Daiwa Bank
다이와 은행
Japan

2064
Seoul Trust Bank
서울신탁은행
Korea

2065
Iyo Bank
이요 뱅크
Japan

2066
Fuji Bank
후지뱅크
Japan

2067
UCB-Bank France
France

2068
First National Bank
국립 내셔널 뱅크
South Africa

2069
Chungbuk Bank
충북은행
Korea

2070
Bank of Tokyo-Mitsubishi
도쿄 미츠비시 은행
Japan

2071
Security Pacific Merchant Bank
시큐리티 퍼시픽 머천트 뱅크
USA

2072
Hong Kong and Sanghai Bank
홍콩 앤 상하이뱅크
Hongkong

2073
Key Bank
키 뱅크
Japan

2074
Mexican/American Bank
멕시칸 아메리칸 은행
USA

2075
VISA Card
비자카드
USA

2076
Master Card
마스터 카드
USA

2077
Debit Card
데빗 카드
USA

2078
Mascot for BC Card 'Hanmaum'
비씨카드 한마음 캐릭터
Korea

2079
Diners Card
다이너스 카드
USA

2080
American Express-Financial Service
아메리칸 익스프레스
USA

2081
Interlink
인터링크
USA

2082
Credit Suisse
스위스 크레디트
Swiss

2083
Mycal Card
미칼 카드
Japan

2084
Eurocard International
유로카드
Brussels

2085
Mascot for BC Card
비씨 카드 마스코트
Korea

2086
BC Card
비씨 카드
Korea

2087
Oita Ken Credit Cooperativ
오이타 현 크래디트
Japan

2075

2076

2077

2078

2079

2080

2081

2082

2083

2084

2085

2086

2087

2088

2089

2090

2091

2092

2093

2094

2095

2096

2097

2098

2099

2100

2088
Community Credit Cooperatives
새마을금고
Korea

2089
Shinsegi Investment Trust
신세기투자신탁
Korea

2090
TM Bank
대구종합금융
Korea

2091
Kyungll International Merchant Bank
경일종합금융
Korea

2092
Central Banking Corporation
중앙종합금융
Korea

2093
Korea Institute of Korea
한국금융연구원
Korea

2094
Hyundai International Merchant Bank
현대종합금융
Korea

2095
Samsam Investment & Finance
삼삼종합금융
Korea

2096
Daehan Investment & Finance
대한종합금융
Korea

2097
Nara Investment & Finance
나라종합금융
Korea

2098
Thomas Hayward-Auctioneer
더마스 헤이워드
USA

2099
Institute of Canadian Bankers
캐나다 은행연구원
Canada

2100
Banca Popolare Sub Puglia
Italy

2101
Dai ichi Securities
다이이치 증권
Japan

2102
Dongsuh Securities
동서증권
Korea

2103
Kankaku Securities
칸카쿠 증권
Japan

2104
Korea Development Securities
한국산업증권
Korea

2105
Cheil Securities
제일증권
Korea

2106
The Nasdaq Stock Market
나스닥 스톡 마켓
USA

2107
Daeyu Regent Securities Co., Ltd.
대유리젠트 증권
Korea

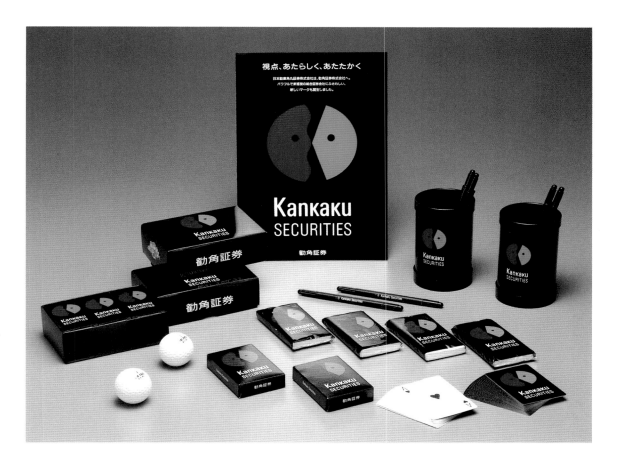

2103

2101

2102

2104

2105

2106

2107

WORLD
SECURITIES

2108

2109

2110

2111

증권예탁원

2112

2113

2114

2115

Daihyaku
Life

2116

2117

2118

2119

2108
World Securities Co.,Ltd
세계증권
Japan

2109
Dongnam Securities Co., Ltd.
동남증권
Korea

2110
Korea Guarantee Insurance Company
대한보증보험
Korea

2111
The Korea Securities Dealers Association
한국증권연합회
Korea

2112
Korea Securities Deposite
한국 증권예탁원
Korea

2113
Mascot for Daewoo Securities Co., Ltd.
대우증권 마스코트
Korea

2114
Financial Security Assurance
파이넨션 시큐리티 어슈어런스
USA

2115
NBV
Netherland

2116
Daihyaku Life
다이하쿠 라이프
Japan

2117
France Life Insurance Assurance
프랑스 생명보험협회
France

2118
The Mutual Life Assurance Company of
Canada
캐나다 뮤추얼 라이프 어슈어런스
Canada

2119
korea Stock Exchange
한국증권거래소
Korea

2120
Prudential Insurance
푸르덴셜 보험
USA

2121
Continental Insurance
콘티넨탈 보험

2122
The Travelers Insurance Corp.
여행보험사
USA

2120

2121

2122

2123

2124

2125

2126

2129

2123
Daehan Life Insurance
대한생명
Korea

2124
Atlantic Mutual Companies
애틀란틱 뮤추얼 컴파니스
USA

2125
Allstate Insurance Companies
올스테이트 보험회사
USA

2126
The Robert Plan Corporation
로버트 플랜
USA

2127
Samsung Life Insurance
삼성생명
Korea

2128
Noble County-Samsung Life
Insurance Silver Town
노블카운티-삼성생명 실버타운
Korea

2129
Mascot for Samsung Life Insurance
삼성화재보험 캐릭터
Korea

2130
Tokio Marine
토키오 해상
Japan

2127

2128

2130

2131
Cheil Life Insurance Company
제일생명보험
Korea

2132
Kukje Hwajae Insurance Co.,Ltd
국제화재
Korea

2133
Daido Mutual Life Insurance Company
다이오 뮤추얼 생명보험
Japan

2134
Samshin Insurance
삼신생명
Korea

2135
LMI Group-Insurance
LMI 그룹
Canada

2136
The Yasuda Mutual Life Insurance
아스다 뮤추얼 생명보험
Korea

2137
Provident Mutual Life Insurance Co.
프로바이던트 무츄얼 생명보험

2138
Transamerica, Inc.
트랜스아메리카
USA

2139
Hanil Life Insurance
한일생명
Korea

2140
Independent Insurance Agent
인더팬던트 보험
USA

2141
State Farm Insurance Co.
스테이트 팜 보험
USA

2142
Cigna Insurance
시그나
USA

2131

2132

2133

2134

2135

2136

2137

2138

2139

2140

2141

2142

2143

2144

2145

2146

2147

2148

2149

2150

2152

2151

2153

2143
Mitsui Marine Co., Ltd.
미츠이 해상
Japan

2144
Dongboo Life Insurance Company
동부화재해상보험
Korea

2145
Nippon Life Insurance Company
니폰 생명보험
Japan

2146
Cheil Insurance
제일화재
Korea

2147
American Loss Control Corp.
아메리칸 로스 콘트롤
USA

2148
Metropolitan Life Insurance Company
메트로폴리탄 생명보험
USA

2149
Hyundai Marine Co., Ltd
현대해상
Korea

2150
Mutual of Omaha Insurance Company
뮤추얼 오마하 생명보험
USA

2151
Korea Education Insurance
대한교육보험
Korea

2152
Kukmin Life Insurance
국민생명
Korea

2153
ITT Hartford
ITT 하트포드
USA

2154
Magna-Security Software
매그너
USA

2155
Guardsmark
가드즈 마크
USA

2156
Pinkerton
핑커튼
USA

2157
Premisys Security System
프레미시스
USA

2158
Security Pro USA
미국 프로경비
USA

2159
SPS Security
France

2154

2155

2156

2157

2158

2159

2160

2161

2162

2163

2164

2165

2166

2160
Allied Security Systems
어라이드 시큐리티 시스템
USA

2161
Constant Security Services
컨스턴트 시큐리티 서비스즈
USA

2162
Aduance Security
아듀언스 시큐리티
USA

2163
Instituto Maxicano del Seguro Social
Mexico

2164
Norinchukin Securities Co.,Ltd.
노린츠킨
Japan

2165
S1 Corporation
주식회사 에스원
Korea

2166
Tele Cap
텔레 캅
Korea

2167
Knight Japan
나이트 제팬
Japan

2168
Secom Malaysia
세콤 말레이시아
Malaysia

2169
Citic Security Ltd
씨틱 경비
Hong Kong

2170
Spider Securities
스파이더 시큐리티
USA

2171
Secom
세 콤

2172
Night Owl Security
나이트 아우얼 시큐리티
USA

2173
Senon
세논

2174
Chicago Crime Control
시카고 크라임 컨트롤
USA

2175
Maruwa Co., Ltd
마루와
Japan

2176
Sambo
삼보 시스템
Korea

2177
The Anvil Group Inc.
앤벌그룹
USA

2167

2168

2169

2170

2171

2172

2173

2174

2175

2176

2177

2178

2179

2180

2181

2182

Asahi Security Systems

2183

2178
SOK

2179
Korea Security Service
Korea

2180
Shield Security
USA

2181
U.S. Security Associates, Inc
USA

2182
Miwa Lock-Door Lock System
Japan

2183
Asahi Security Systems
Japan